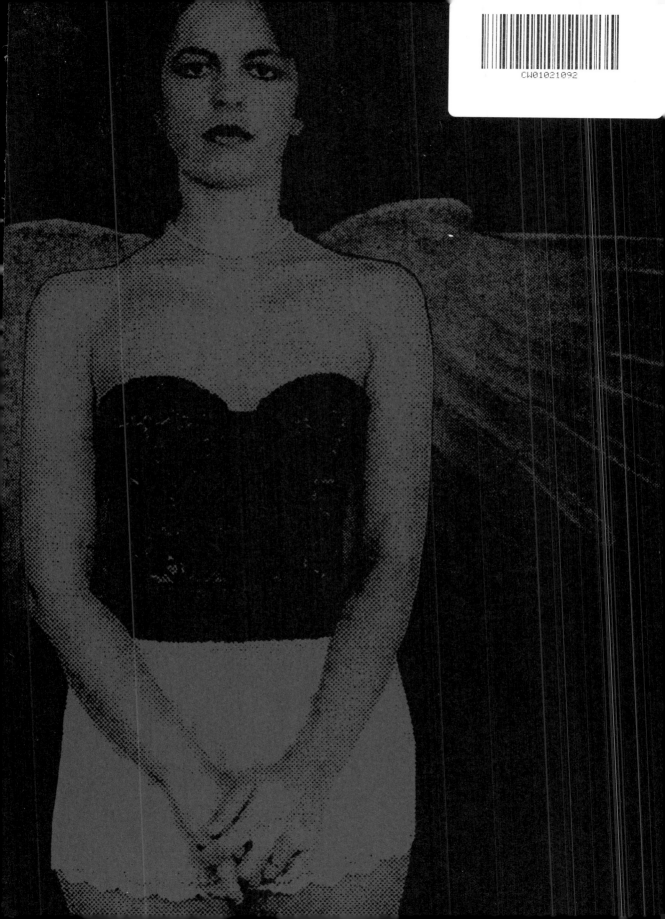

CW01021092

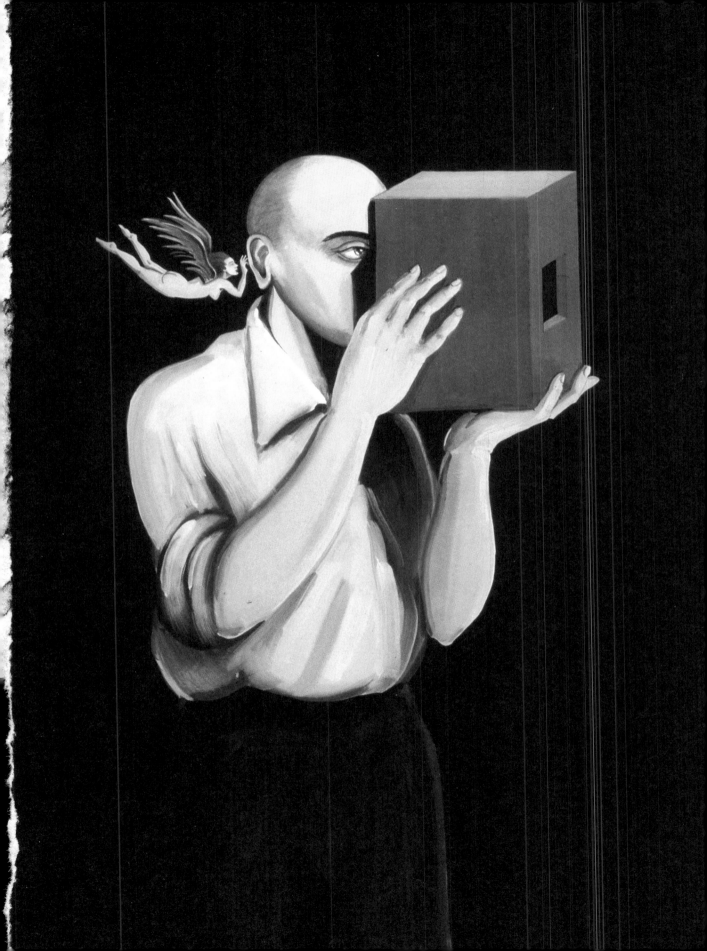

First published by
SelfMadeHero
139-141 Pancras Road
London NW1 1UN
www.selfmadehero.com

© Illustrations and text by Andrzej Klimowski
© Introduction by David Crowley

Original artwork by Andrzej Klimowski
Cover illustration: Andrzej Klimowski
Cover and layout design: Jeff Willis

Publishing Director: Emma Hayley
Sales & Marketing Manager: Sam Humphrey
Editorial & Production Manager: Guillaume Rater
Layout designer: Kate McLauchlan
UK Publicist: Paul Smith
US Publicist: Maya Bradford
With thanks to: Dan Lockwood, Piotr Dąbrowski Poster Gallery
(www.theartofposter.com), Andrew Richardson and Natalia
Klimowska-Nassar

This book was published with the support of the Polish Cultural
Institute in London.

All rights reserved. No portion of this book may be reproduced,
stored in a retrieval system, or transmitted in any form or by
any means, mechanical, electronic, photocopying, recording, or
otherwise, without written permission from the publisher.

A CIP record for this book is available from the British Library

ISBN: 978-1-910593-46-2

10 9 8 7 6 5 4 3 2 1

Printed and bound in Slovenia

KLIMOWSKI
POSTER BOOK

SELF
MADE
HERO

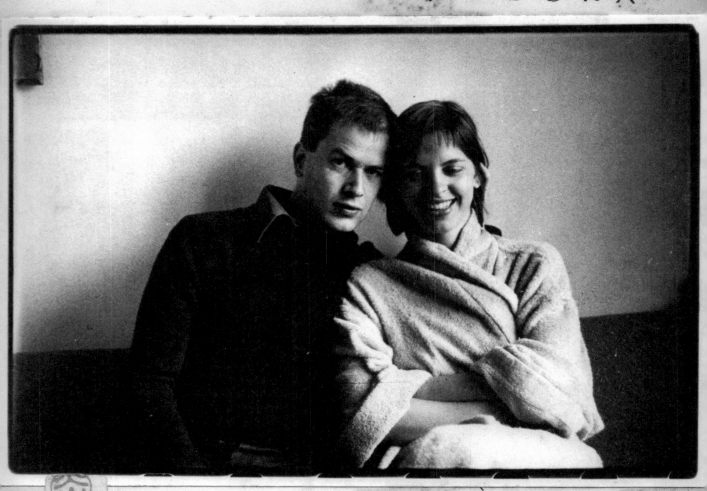

Andrzej Klimowski and Danusia Schejbal, Warsaw, 1974.

Andrzej Klimowski

WARSZAWA
al. Przyjaciół 1 m18.
tel. 28 98 85

Akademia Sztuk Pięknych
wydział grafiki
Prac. prof. H. Tomaszewskiego

KRAKOWSKIE
PRZEDMIEŚCIE
WARSZAWA
P O L S K A

1974

In 1980, English-born Andrzej Klimowski had been living in Warsaw for seven years and was working as the designer of posters for the state film distributor and a number of theatres around Poland. That year, he put his commissions on hold to make a film for the Se-Ma-For film studio in Łódź. The studio had a good reputation for experimental short films and animations, and gave even novice film-makers like Klimowski access to 35mm cameras, professional lighting rigs and skilled technicians. It was one of a number of surprisingly free zones of artistic expression in the People's Republic of Poland.

Entitled *Martwy Cień* (*Dead Shadow*), Klimowski's ten-minute film lays out the symbols and themes that he had already been exploring in posters for most of the 1970s, and that continue to occupy his imagination almost forty years later. A man sits at home, sleeping. We are granted access to his dreams and nightmares, many of which are haunted by the face of a woman. Her photographic portrait looks down from the wall of the apartment, framed alongside others from an earlier age. She also appears in print: the man leafs through an album of Victorian monuments and Renaissance mausoleums and churches, before turning to a newspaper which features her portrait framed with a black border. The mood of the film is intensely introspective (an atmosphere heralded by a rapid descent down a musical scale before the action starts). Full of memories and desires, the home in *Martwy Cień* is what art historian Andrzej Turowski has called a 'utopie rétrospective'.[1] Such places idealise settings and times – like the homes of childhood – which can no longer be accessed. The only incursion of the world outside the home comes in the form of a flickering television screen on which the same woman appears as a news presenter introducing reports of military violence and police brutality. In the final scene, she features as if in 'real' life, only to turn to a deathly mask when embraced by the man. Whether as photograph, as half-tone illustration on the printed page, as video or as celluloid, she is a 'dead shadow' who haunts the present.

The woman was not a new discovery. She had already starred in many of Klimowski's posters: in dark eye make-up in his design for Olea's film *Torment* (1974); with foaming hair and in profile for the publicity for Robert Altman's movie *Nashville* (1975); and, three years later, brightly decorated with stage paint and peering out from the stage curtains to announce the thirtieth anniversary of the Współczesny Theatre in Wrocław. Yet she was not an actress. She was and is Danusia Schejbal, a theatre designer, Klimowski's wife and sometimes his creative partner (most recently in their joint graphic memoir of life in Poland in the 1970s[2]). Her appearance in his work may be explained pragmatically as the convenience of having a model 'on call'. Or it may be explained emotionally, as an expression of love and desire. But this intimacy also opens up the prospect of viewing the men who feature in his images as self-portraits (even if the man in *Martwy Cień* was not played by Klimowski himself) and the poster as a vehicle for some kind of self-inspection.

The mass-produced poster seems like an unlikely medium for this kind of turn inward. After all, modernist design theory had emphasised the poster's public duties. Famously, A.M. Cassandre, the celebrated French designer, laid out the case for the poster as a kind of impersonal medium in 1933: "The poster is only a means to an end, a means of communication between the dealer and the public, something like telegraphy. The poster plays the part of the telegraph official: he does not initiate news, he merely dispenses it."[3] But the conditions which prevailed in the People's Republic of Poland when Klimowski began his career released the poster designer from the pressures of commercialism or even the task of accurate delivery of information. Hardly required to 'sell' seats in cinemas and theatres, and benefiting from a strong belief in the autonomy of the artist which was shared by many working in the arts, poster designers probably enjoyed more freedom of expression than their counterparts in the West. Posters had to pass through the state censor's

1 Andrzej Turowski, *Existe-il un art de l'Europe de l'est? Utopie et idéologie* (Paris, 1986), p.265.
2 Andrzej Klimowski and Danusia Schejbal, *Behind the Curtain* (London, 2015).
3 Cassandre cited in David Crowley and Paul Jobling, *Graphic Design: Reproduction and Representation since 1800* (Manchester, 1996), p.149.

office, but were rarely banned. Klimowski recalls only one such incident – when the film distributor required that his poster for *Torment* be reworked before it was sent to the censor. He recalls:

> The Communist state was very careful not to aggravate the Church. There was a Spanish film about a priest who was under the control of a woman, unable to escape her influence. I made a photograph of Danusia naked from the back. I had to use a delay timer because I had my hands around her, holding a cross and bound in a rosary. The response was outright no. The publisher said the censor wouldn't pass it.[4]

When commissioned to promote imported movies like *Torment*, poster designers in Poland had little access to publicity photographs and might not even see the film in advance. Instead, they might be given a plot summary by the distributor. And in the case of theatre, the posters had to be printed long in advance of the premiere. Often, all that was available to the poster designer was a script or libretto. In such circumstances, poster design was, necessarily, an act of fantasy and improvisation. This added greatly to their autonomy. After his return to the UK in 1981, Klimowski continued to work in much the same way. His intuitive approach to the image was hardly suited to the regimes of market research and PR which shape publicity in the business-minded world of graphic design in the West, and so while the supply of poster commissions continued, they were never to be as plentiful again.

Klimowski's posters, book jackets, illustrations and his film *Martwy Cień* evade simple interpretation, yet the repertoire of images and devices which appear in his works is remarkably concise and constant. The repeated overlay of one person's eye on another's face or the attachment of wings to a human torso are not arbitrary combinations, guided by some kind of surrealist fascination with the effects of chance. These gestures recur so frequently that they are more like Klimowski's own *idées fixes*. And if the meanings that might be attached to such montages

cannot be precisely determined, say in the manner of a rebus or even an allegory, they are best understood as poetic metaphors, sometimes for what cannot be seen. In fact, many of Klimowski's poster images and illustrations allude to blindness or to what might be called 'displaced' sight: a 1988 poster produced to promote the 28th Short Film Festival in Kraków features a transparent blindfold through which, paradoxically, light emanates; in others, like the posters for Jacques Deray's movie *Flic Story* (1976) and Tadeusz Różewicz's play *Kartoteka* (1984), or a performance of Richard Wagner's *Flying Dutchman* at Warsaw's Teatr Wielki (1981), a human face is either hidden or abruptly cut off. Sometimes, the eye has left its conventional position altogether: for an adaptation of Botho Strauss's *Die Zeit und die Zimmer* (1993), for instance, a large eye peers back at the viewer from the frame formed by the crooked arm of a woman holding her head. Is the eye hers? Or yours? Or God's? There is, of course, something capricious about using a medium that is tasked with pleasing the eye to explore blindness or displaced eyesight. But Klimowski seems to be suggesting that external sight must be extinguished for internal vision to flourish.

Klimowski is by no means alone in making this suggestion. Late in life, philosopher Jacques Derrida was invited to curate an exhibition at the Louvre in Paris. True to his deconstructive method, he set out to expose that which had been repressed in an institution which was a cornerstone of Western art history. The result was his *Memoirs of the Blind*, an exploration of the images of non-seeing in the museum's vast collection displayed in the Napoléon Hall in 1990-91. Classical mythology and the Bible have provided dozens of instances of blindness – usually as divine punishment – for artists to envision. In the accompanying publication, the philosopher placed particular attention on drawing, arguing that even those artists who draw their subject *d'après nature* face two orders of blindness. Attentive to the drawing in hand, he or she is blind to the

[4] This quote and all others from an interview with Andrzej Klimowski, London, August 2017.

subject, and when gazing on the subject is blind to the drawing. What holds these activities together is resorting to memory and experience – forms of what Derrida calls 'auto-reflection'. A drawing by a blind person – perhaps using touch to 'see' the world – is a kind of doubling, too: "If to draw a blind man is first of all to show hands, it is in order to draw attention to what one draws with the help of that with which one draws, the body proper [*corps propre*] as an instrument, the drawer of the drawing, the hand of the handiwork, of the manipulations, of the manoeuvres and matters, the play or work of the hand – drawing as surgery."[5]

Klimowski has in recent years spent much of his time drawing, not least the panels of the graphic novels he has authored since his first, *The Depository*, in 1994. But his posters continue his long-standing practice of photomontage, involving the excision and combination of images from existing printed sources. This is its own form of 'drawing as surgery'; one in which different orders of image – whether wood-engravings in medieval bestiaries, half-tones from the illustrated press or plates from the Victorian illustrator Gustav Doré's books – are sutured together and then photographed for reproduction. Photomontage allows for repetitions and collisions, as well as abrupt shifts of perspective and distortions of scale. It has a long tradition in the visual arts and cinema, but Klimowski's points to the special impact of reading Latin American writers in the 1970s, not least Argentinian writer Julio Cortázar's short stories in Zofia Chądzyńska's brilliant translations. For instance, in Cortázar's 'Las Babas del Diablo' (which provided the original idea for Antonioni's movie *Blow Up*), a French-Chilean translator and amateur photographer called Michel captures on film a selfish attempt by a woman to seduce a boy on the streets of Paris on a bright November day. Only after he blows up his photo to the size of a poster, one month later, does he realise that he had actually witnessed the efforts of a man to trap the boy. Perhaps this man is the devil suggested by the story's title. By making the print, Michel gives the boy a chance to escape, at least in his imagination.

Shifting perspective, this fragmented short story moves back and forth between first and third person: sometimes Michel explains his actions using the personal pronoun; at others, we observe him from afar. What begins with the bright confidence of a photographer in his ability to reveal the lines of beauty and order that run through Paris ends in breakdown. Michel enters the photograph on his apartment wall:

> ...I realised that I was beginning to move toward them, four inches, a step, another step, the tree swung its branches rhythmically in the foreground, a place where the railing was tarnished emerged from the frame, the woman's face turned toward me as though surprised, was enlarging, and then I turned a bit, I mean that the camera turned a little, and without losing sight of the woman, I began to close in on the man who was looking at me with the black holes he had in place of eyes, surprised and angered both, he looked, wanting to nail me onto the air, and at that instant I happened to see something like a large bird outside the focus that was flying in a single swoop in front of the picture, and I leaned up against the wall of my room and was happy because the boy had just managed to escape...

A human camera, he then frames and focuses the boy's tormentors:

> Out of breath, I stood in front of them; no need to step close, the game was played out. Of the woman, you could see just maybe a shoulder and a bit of the hair, brutally cut off by the frame of the picture; but the man was directly centre, his mouth half open, you could see a shaking black tongue, and he lifted his hands slowly, bringing them into the foreground, an instant still in perfect focus, and then all of him a lump that blotted out the island, the tree, and I shut my eyes, I didn't want to see any more...[6]

[5] Jacques Derrida, *Memoirs of the Blind: The Self-portrait and Other Ruins* (Paris, 1993), pp.4-5.

[6] Julio Cortázar, *Blow Up and Other Stories,* translated by Paul Blackburn (New York, 1968), pp.114-15.

Michel then breaks down in tears, another kind of blindness.

The mysterious symbols in Cortázar's short story, as well as a kind of suspicion of claims on objective reality, bind Klimowski to the Argentinian writer, but it is perhaps the affinities of technique, despite the differences in medium, which are most revealing. "Sometimes within a short story, just four pages long," says Klimowski, "Cortázar could shift reality totally. So a character being observed is, at the end of a story, waiting to be observed. It is a sudden shift. And that shift of two realities is what happens in collage or photomontage." Sometimes these shifts are between worlds, as Michel's step into a photograph taken one month earlier proposes. And, at others, they are shifts in time. Combining both an endless present and a vertiginous sense of the past, this is one of the chief effects of the photograph (of one print showing "two little girls looking at a primitive aeroplane above their village," Roland Barthes writes in *Camera Lucida*, "How alive they are! They have their whole lives before them; but also they are dead."[7]). The possibility of folding different orders of time together also explains the deep interest in photomontage in Communist Poland. So many of the brilliant image-makers working in the country in the 1960s – Roman Cieślewicz, Jan Lenica, Walerian Borowczyk, Daniel Mróz and others – reactivated imagery from the past in their posters, illustrations and animations, often from the lost worlds of their childhoods or even earlier. Eschewing activism and agitation, this is the closest that these artists came to contesting state ideology. Irrational, 'obsolete' and yet highly charged images – portraits of film stars, family photographs, religious imagery and so on – offered the means to tap suppressed values in a socialist society which endlessly trumpeted its rationalism and progress.

Klimowski had close affinities, and in the case of Lenica and Cieślewicz good relations, with these artists, but he belongs to a younger generation. He also brought a strong fascination with patina – the marks of age and time – to his poster designs and other images. In a memorable scene in *Martwy Cień*, the camera tracks right to left across a cityscape composed of photographic images. Neoclassical temples turn into modernist housing. Once pristine, they now seem marked by age. Crumbling walls bear graffiti and torn posters from different times and places: a piece of propaganda in Russian, a French ad and a contemporary poster designed by Klimowski himself (for Richard Donner's film *The Omen*). Similarly, his posters feature imperfections – surfaces are blemished or marked by signs of their making. This was, in part, a matter of necessity. The faulty materials available to artists in Poland in the 1970s and the need to improvise by, say, converting a bathroom into a darkroom had both aesthetic and intellectual effects: "Grit is important," he says. "This dawned on me when I was in the darkroom and I could not get the dust off. I could not avoid getting negatives scratched. So I thought that this is part of it... these bits of hair floating in among the half-dot screens and the scratches. That's texture."

For some commentators sensing the breakdown of the material world of real existing socialism, Poland was too full of texture. Setting the scene for his short story 'A Sense of...', Janusz Anderman wrote:

> Silence and mist covered the vast square: its houses lay in decay, unreal as a stage backcloth; jutting balconies stacked with discarded objects, broken chairs, faded children's toys, scraps of refuse, dusty jars and bottles, saucepans with holes and cracked enamel, voiceless TV boxes, old-fashioned chandeliers, rotting picture frames, rusty bikes, strung-up bundles of old newspapers.[8]

But one suspects that the attraction of grit to Klimowski was not simply a sign of the times – but that in these blemishes and marks signs of vital life were to be found, too.

[7] Roland Barthes, *Camera Lucida*, translated by Richard Howard (New York, 1981), p.96.

[8] Janusz Anderman, 'A Sense of...' in *The Edge of the World* (London, 1988), p.72.

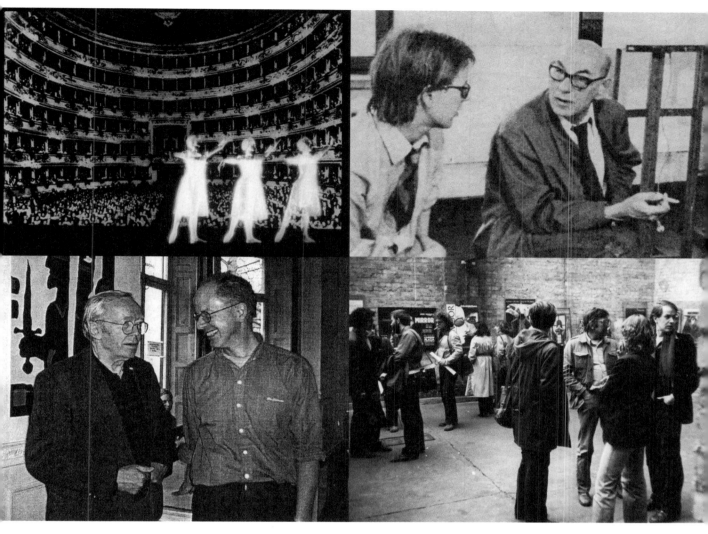

Clockwise from top left:
Still from Martwy Cień (Dead Shadow), 1980.
*Andrzej Klimowski with Professor Henryk
Tomaszewski, Warsaw Academy of Fine Arts, 1974.*
*Andrzej Klimowski Exhibition, Galeria
Wielka 19, Poznań, 1980.*
Jan Lenica and Andrzej Klimowski, RCA London, 1998.

Klimowski celebrates the power of images to elude precise definition. He freely admits that he does not know what the images in his posters and illustrations might mean or even why they recur with such frequency. This is perhaps where their uncanny power lies. And like the woman who haunts the sleeping man in *Martwy Cień* or the devil in Cortázar's short story, it is not clear whether Klimowski sought out his images or if they have found him.

David Crowley,
Dublin, 23 October 2017

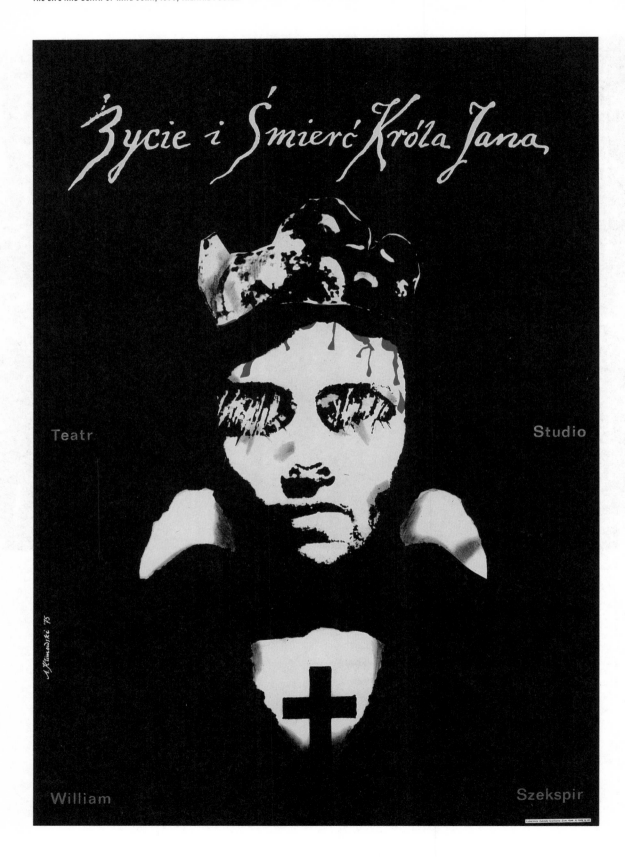

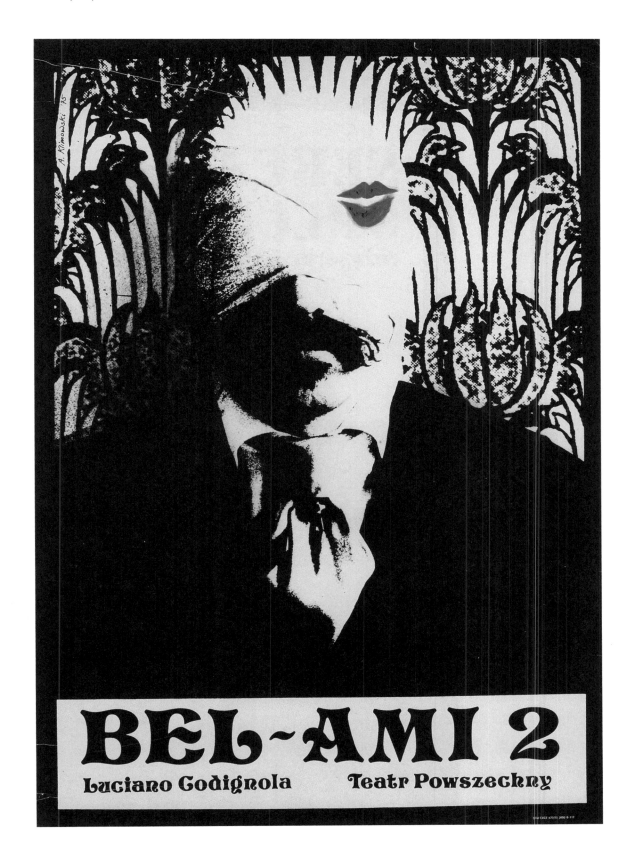

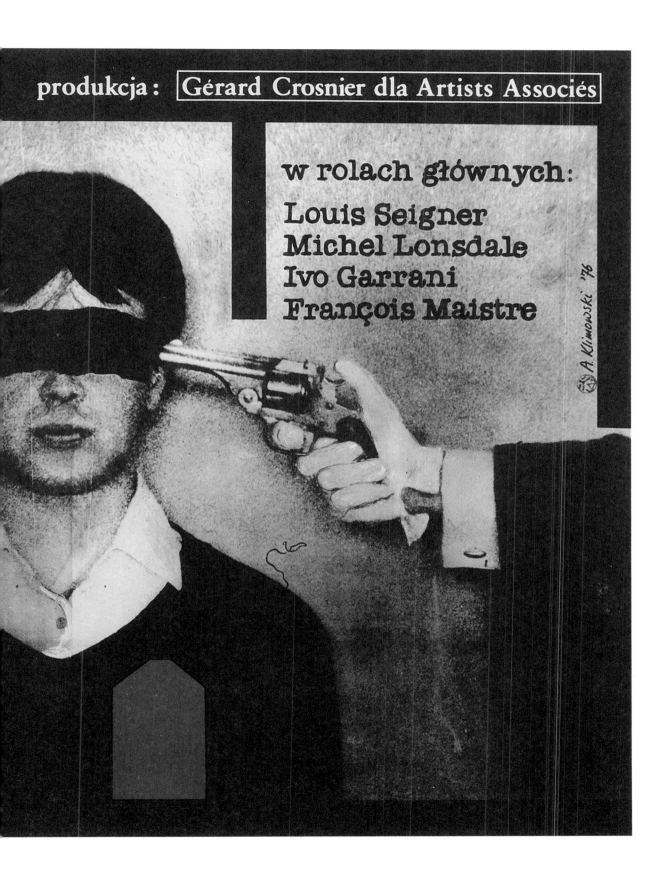

produkcja: Gérard Crosnier dla Artists Associés

w rolach głównych:
Louis Seigner
Michel Lonsdale
Ivo Garrani
François Maistre

A. Klimowski '76

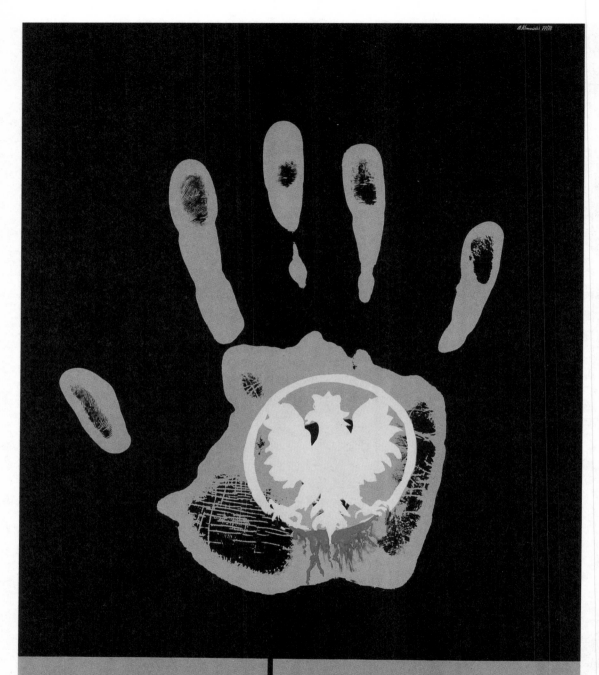

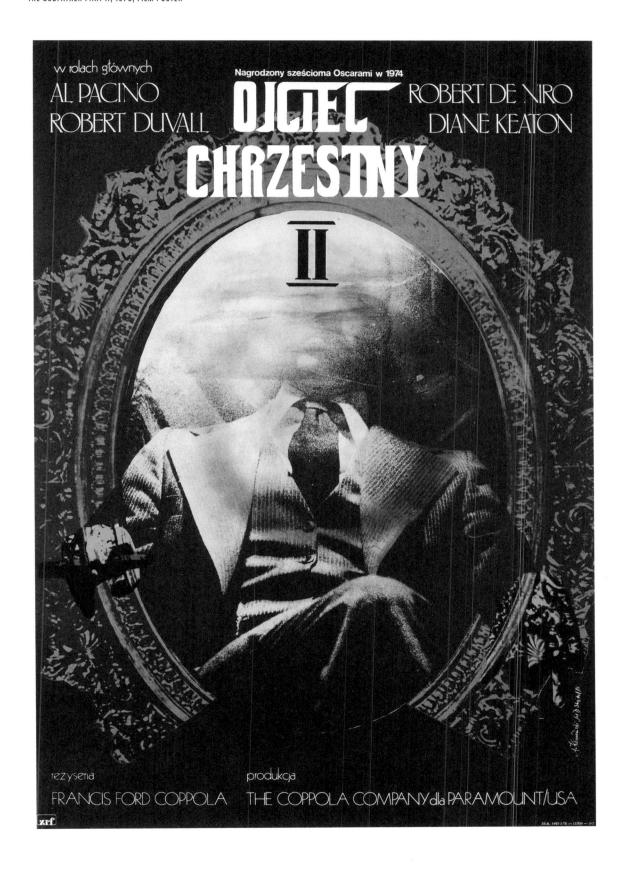

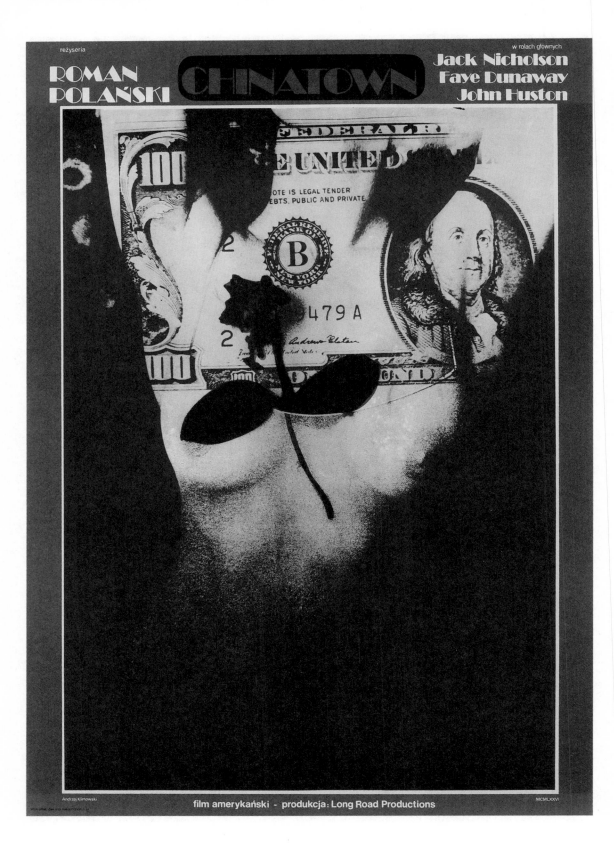

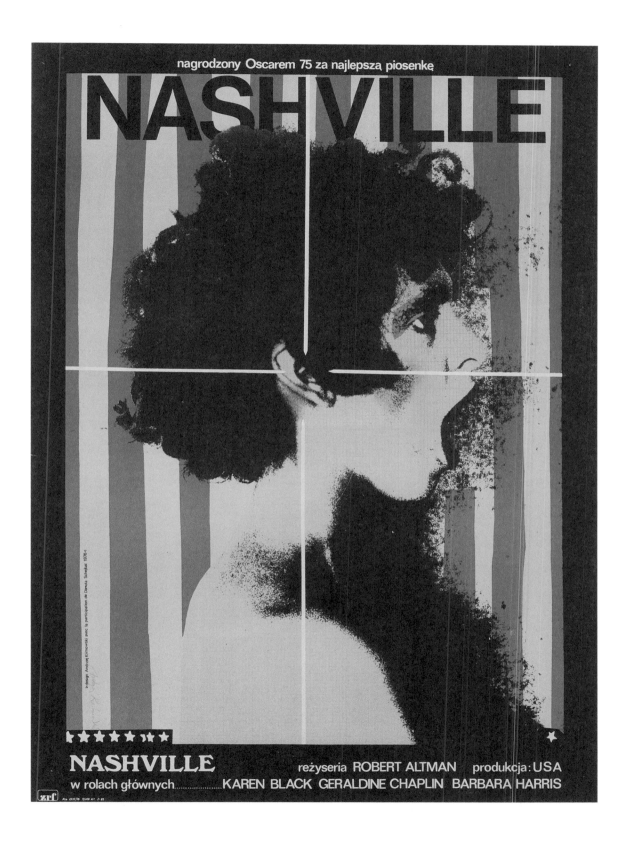

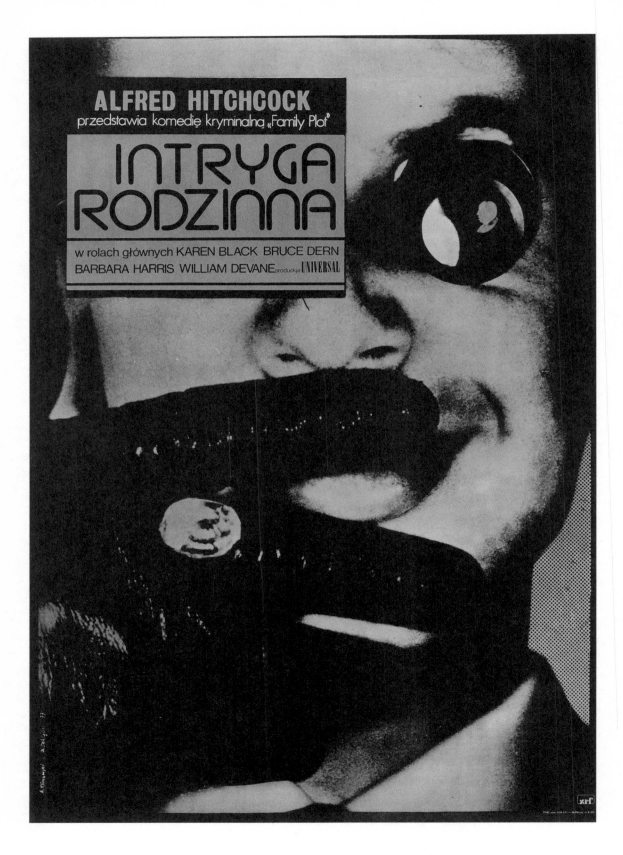

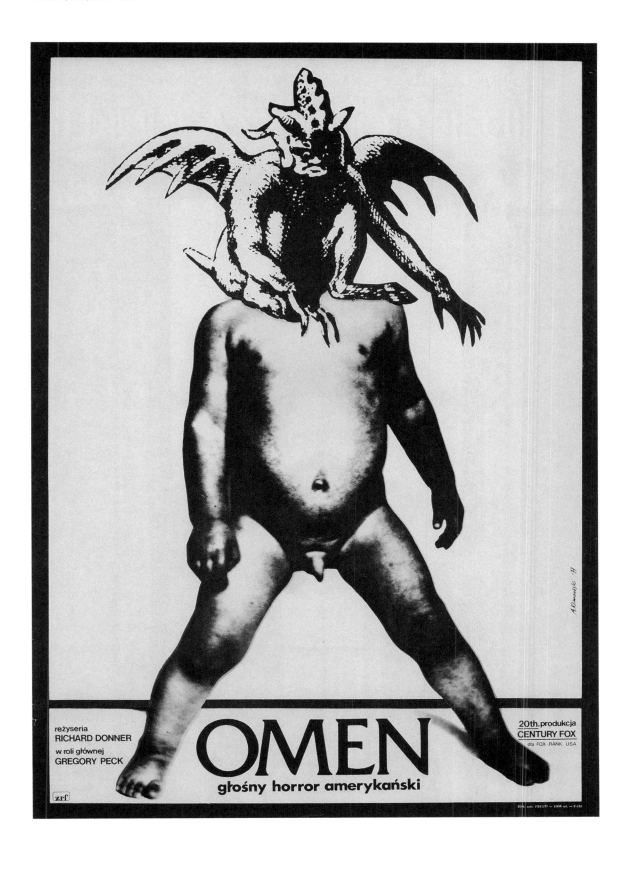

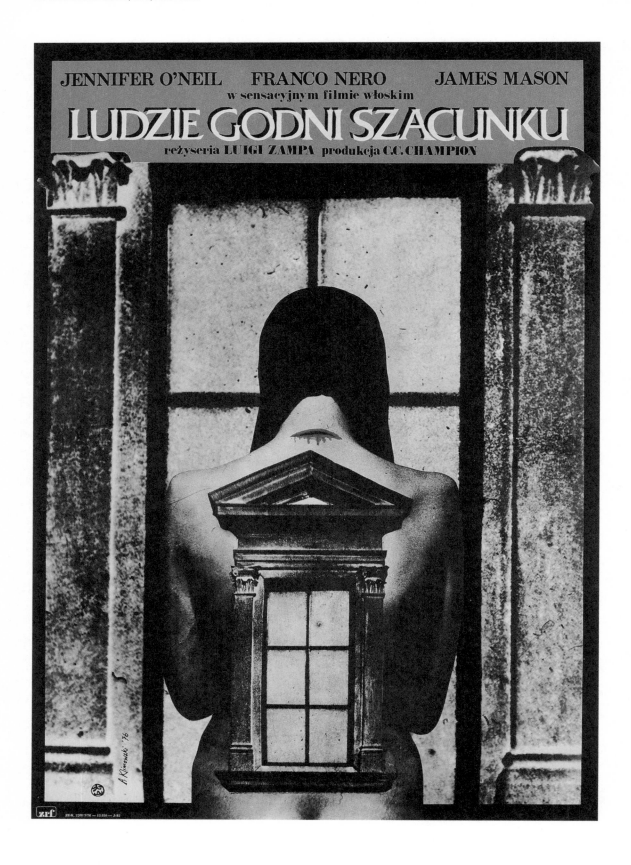

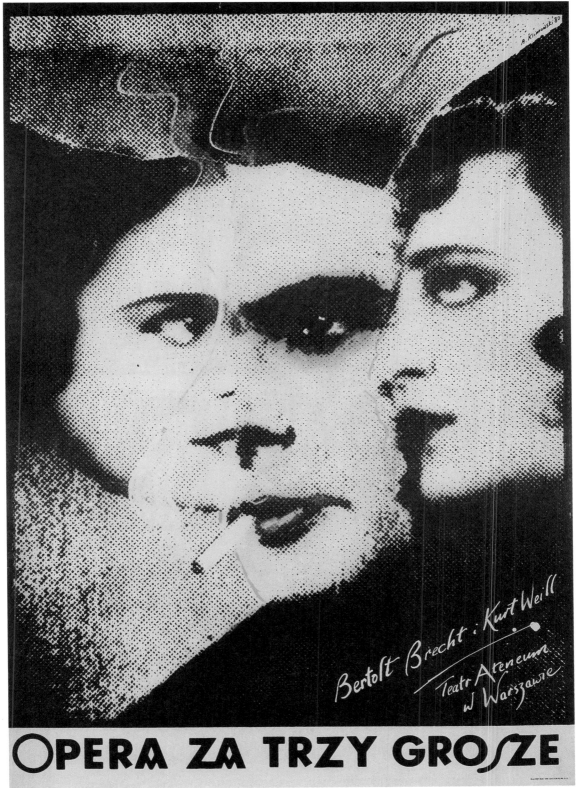

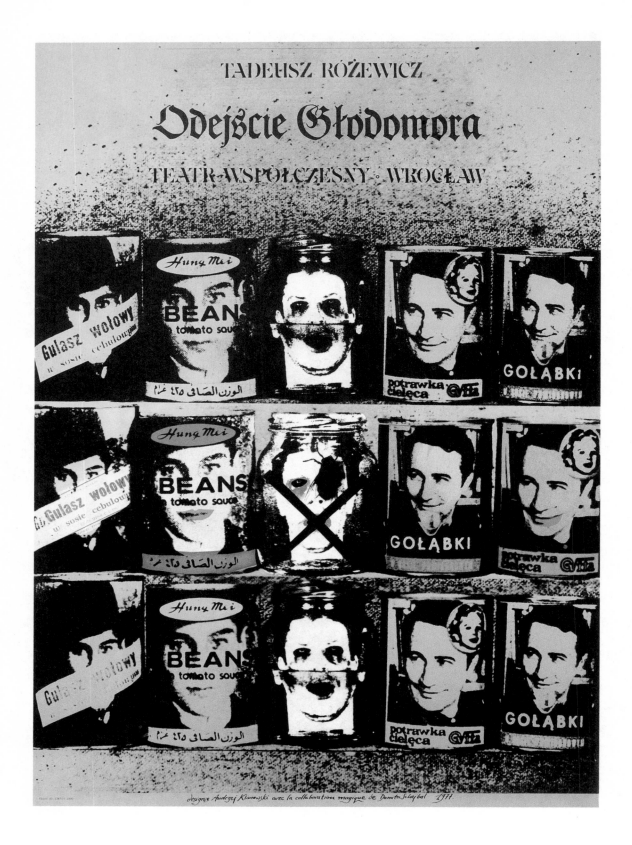

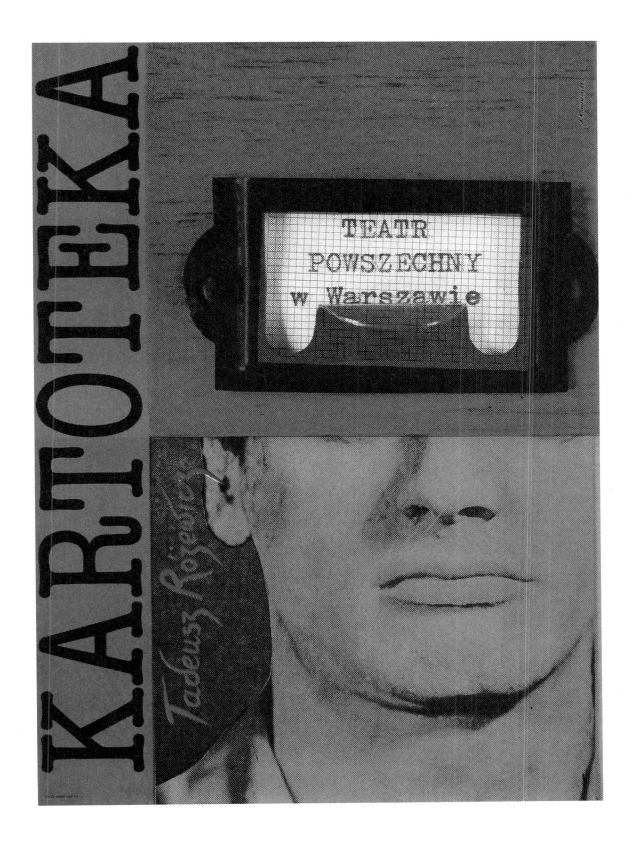

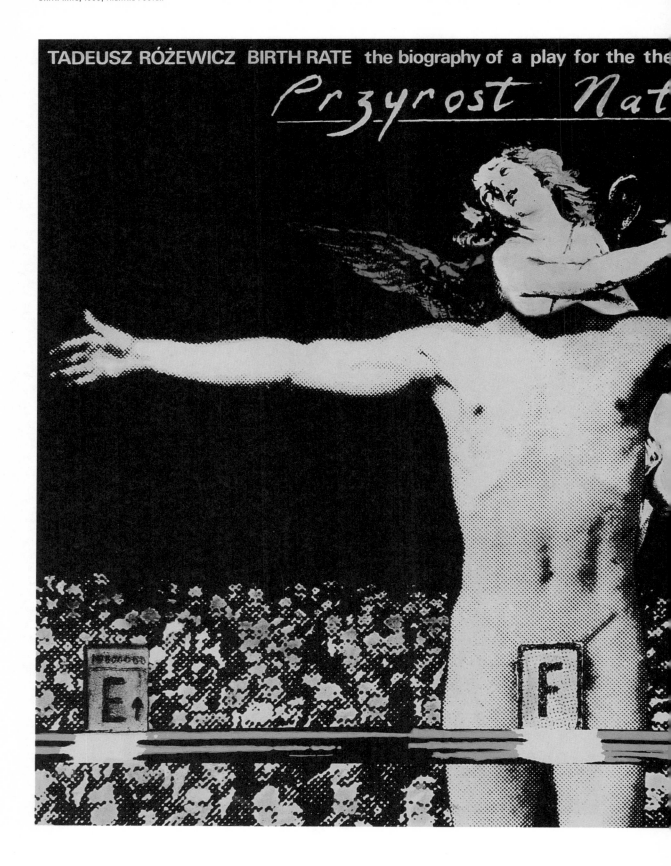

TADEUSZ RÓŻEWICZ BIRTH RATE the biography of a play for the the

Przyrost Nat

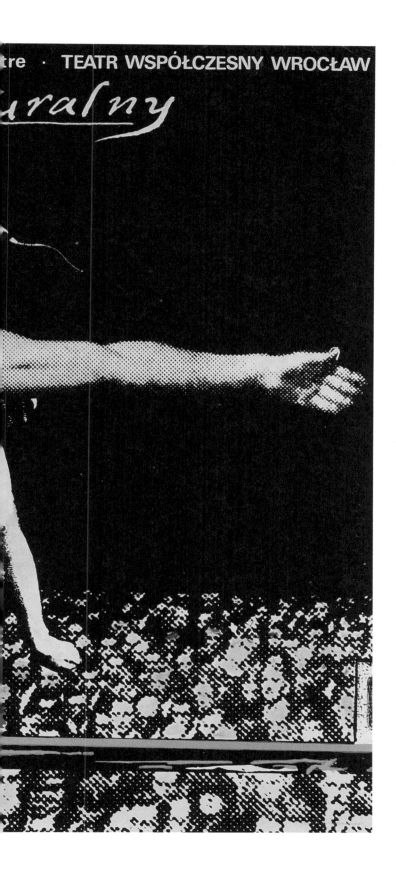

tre · TEATR WSPÓŁCZESNY WROCŁAW

uralny

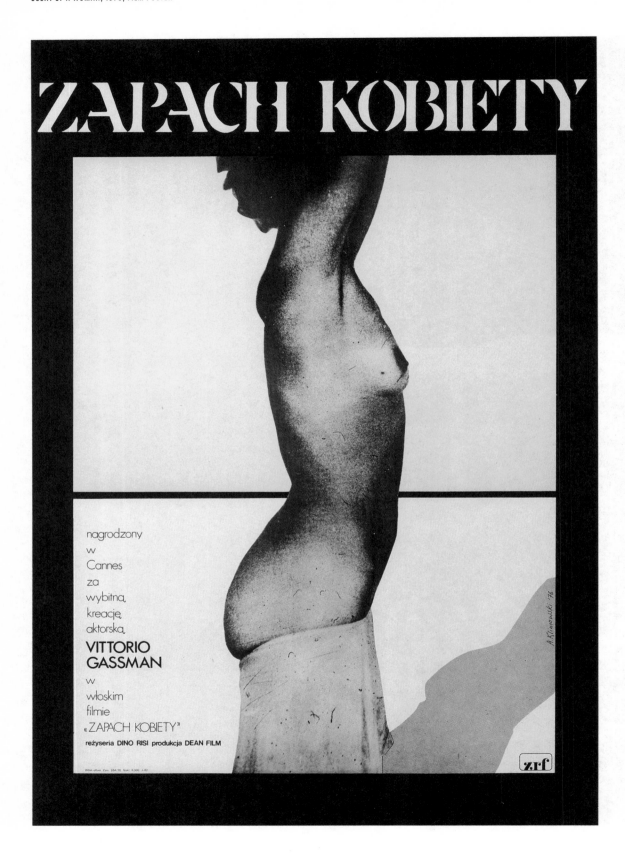

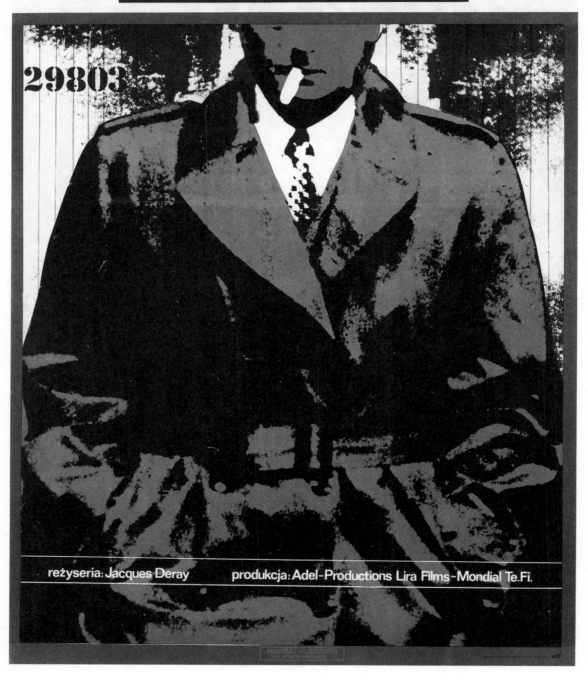

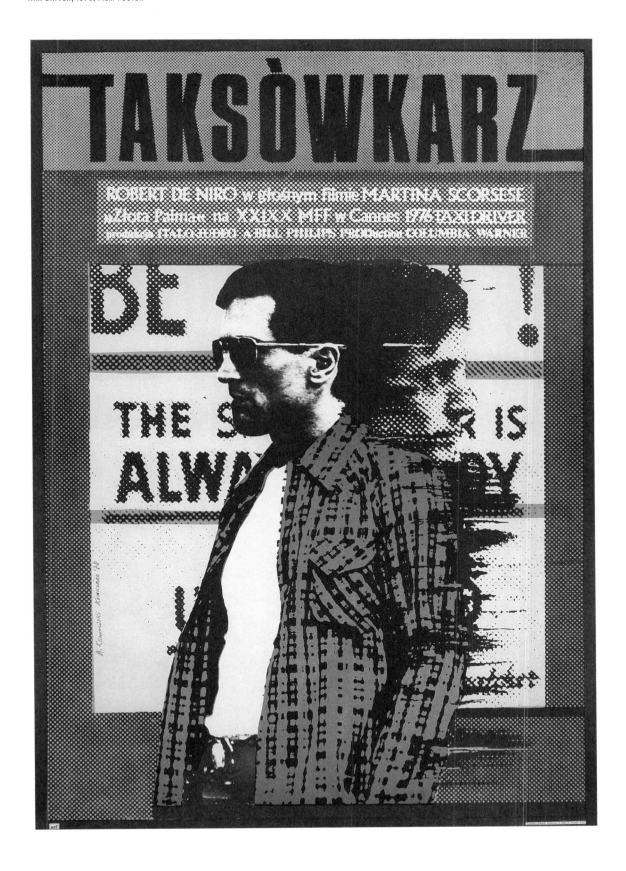

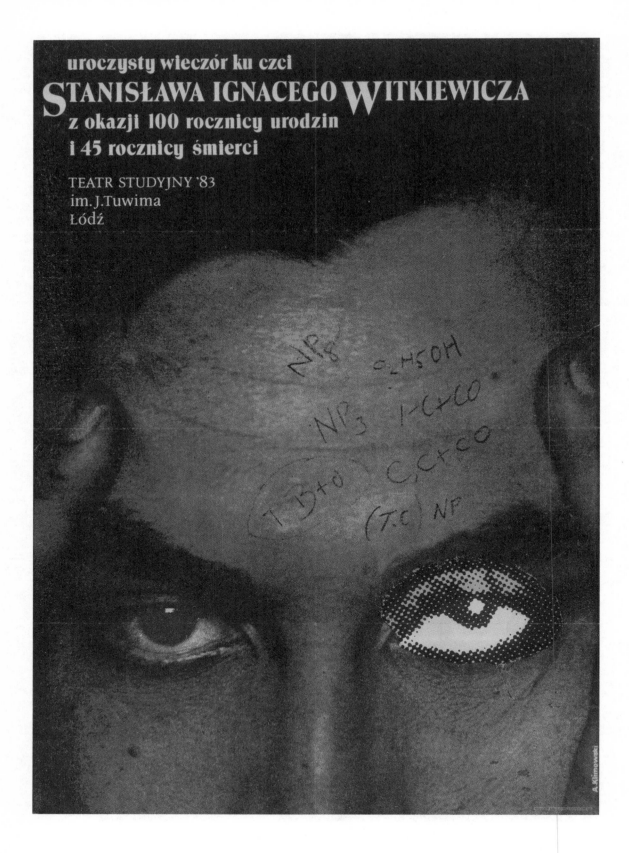

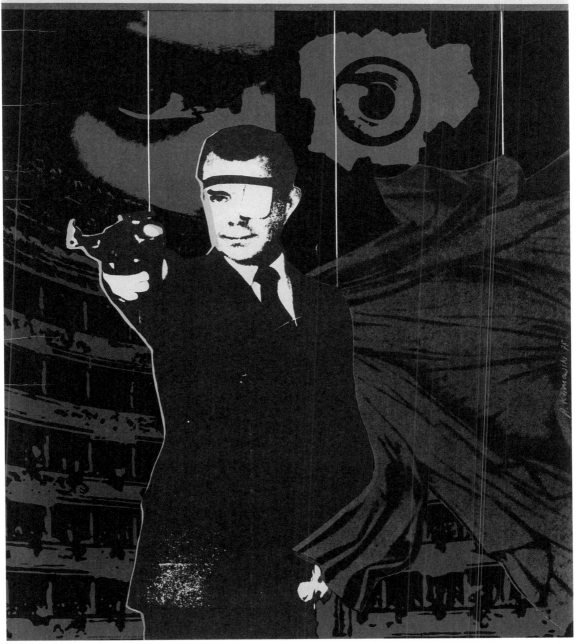

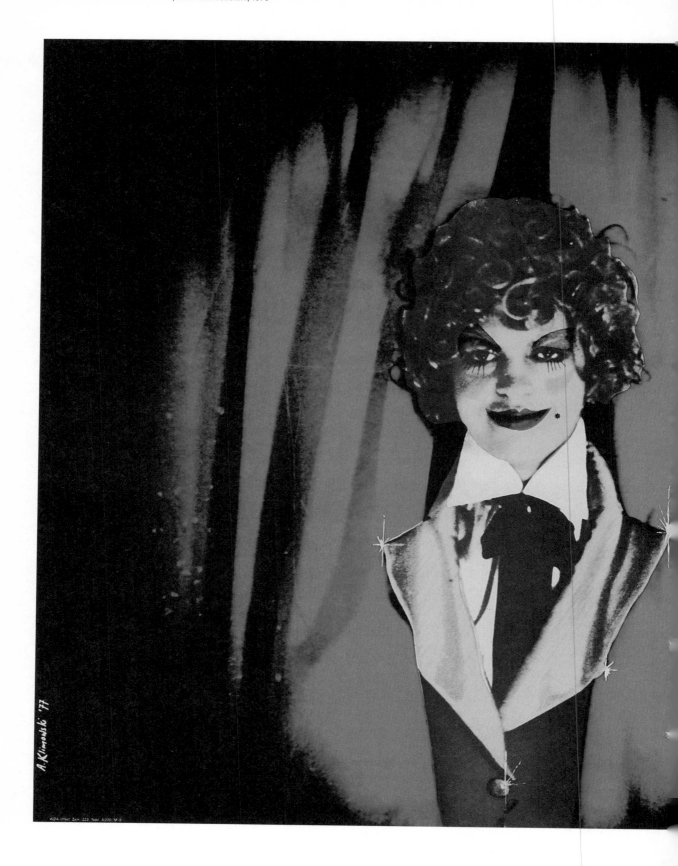

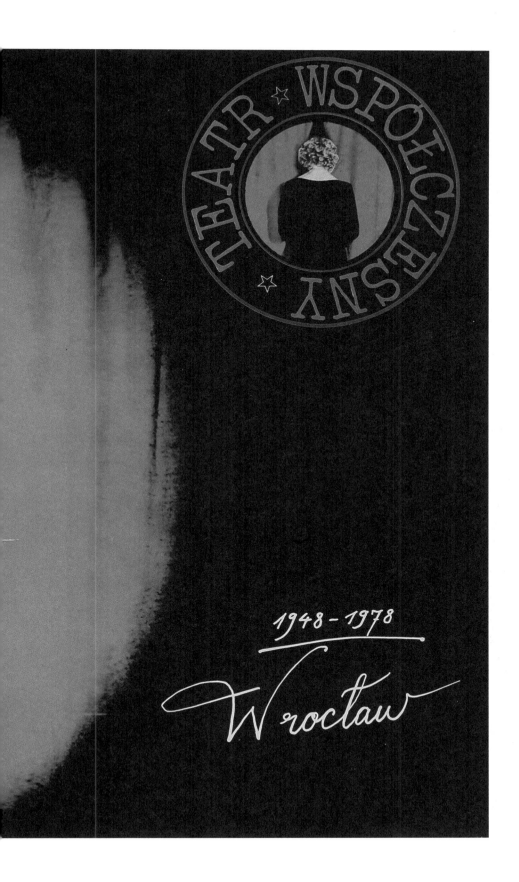

TEATR ☆ WSPÓŁCZESNY ☆

1948 - 1978

Wrocław

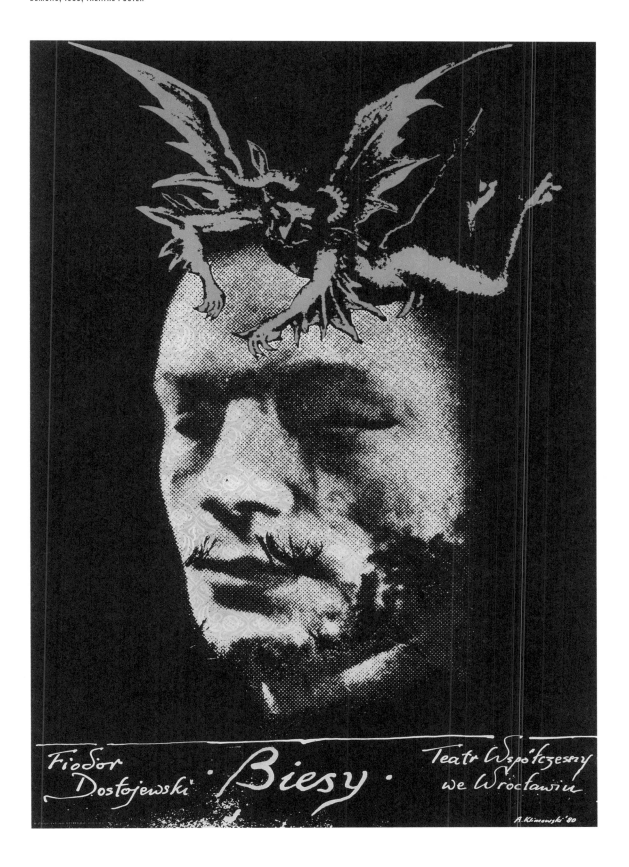

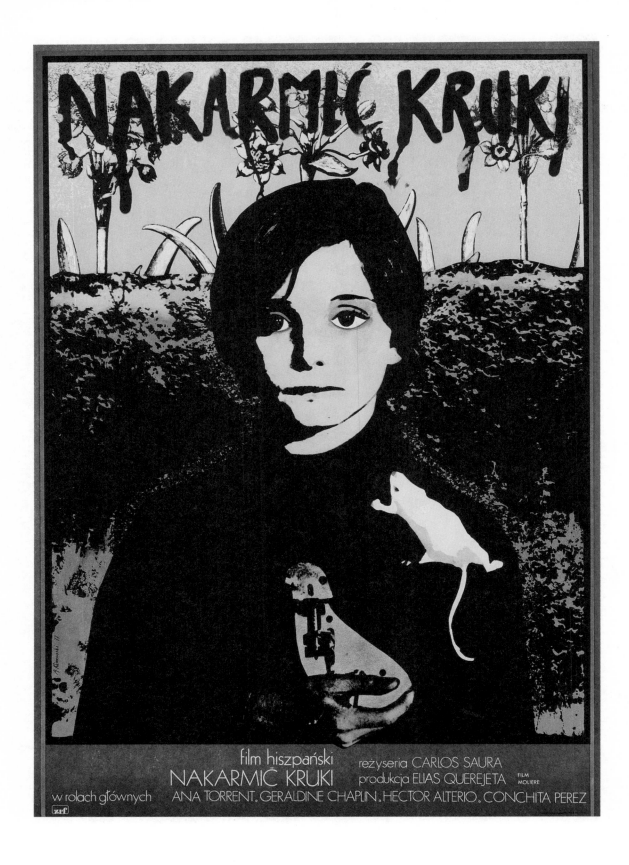

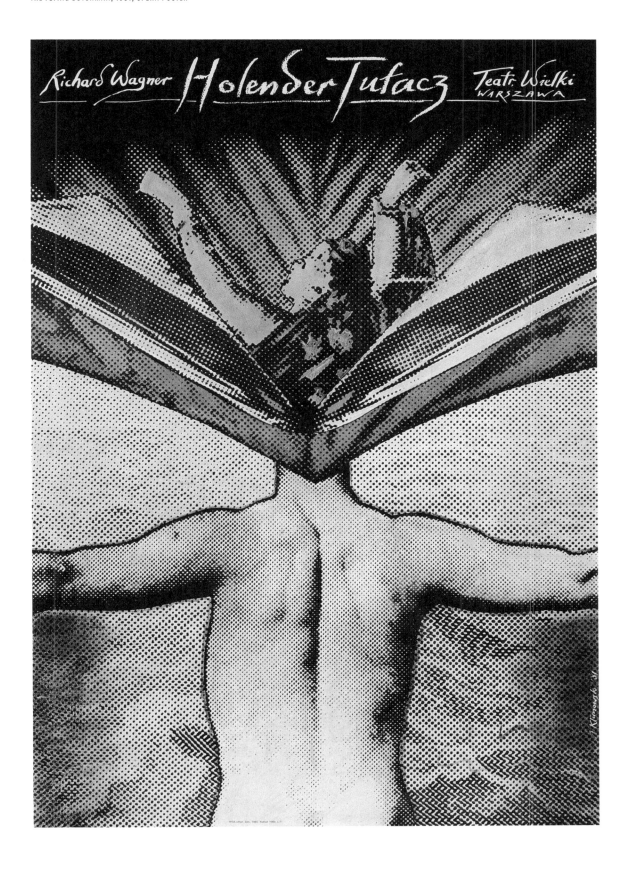

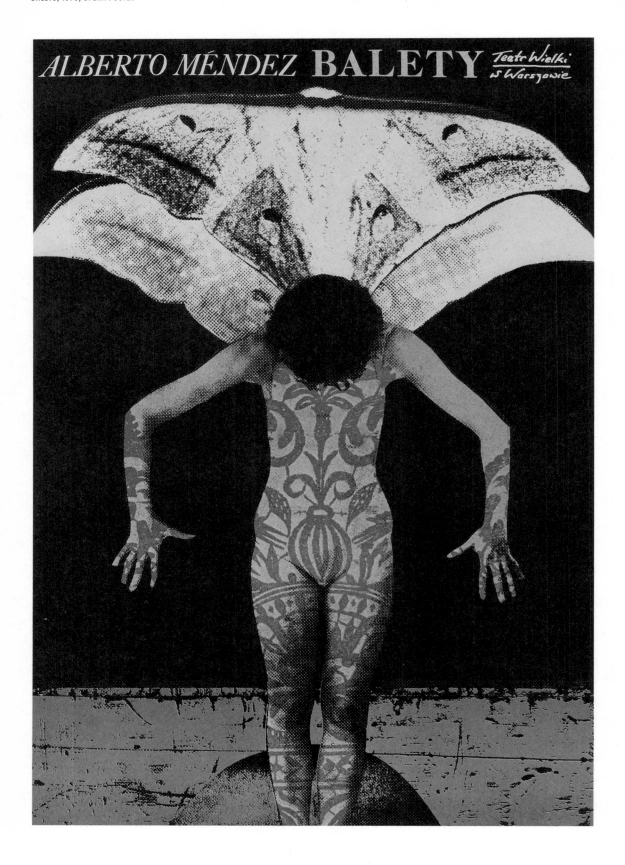

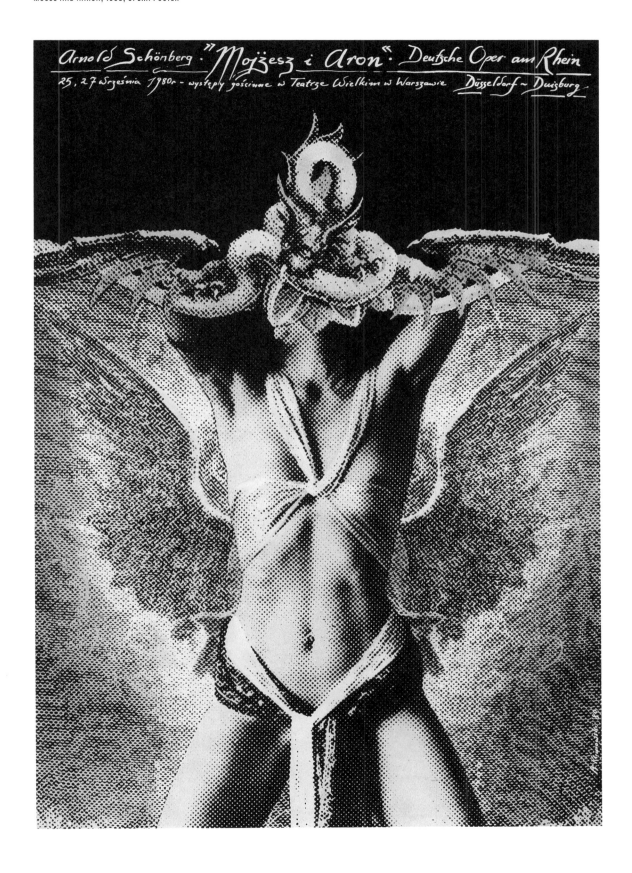

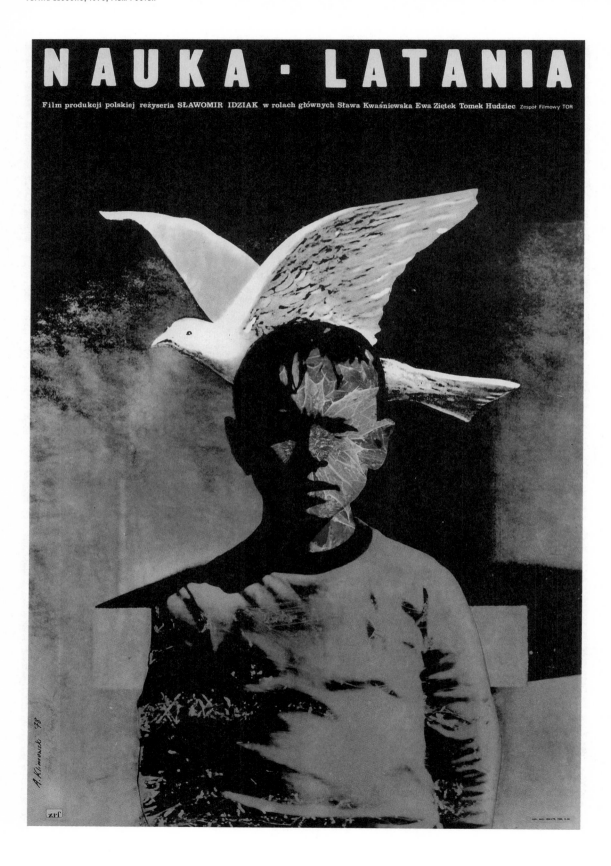

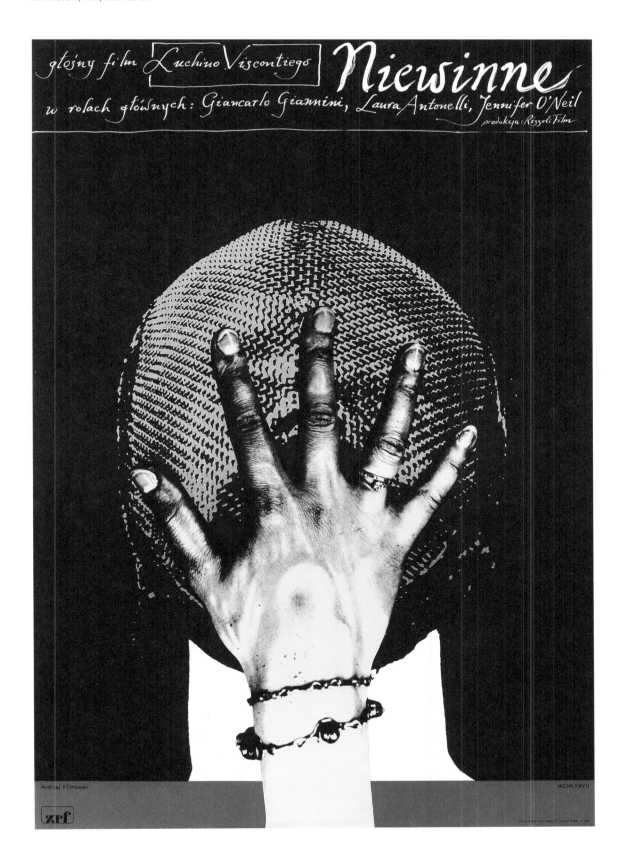

Dzień Drukarza

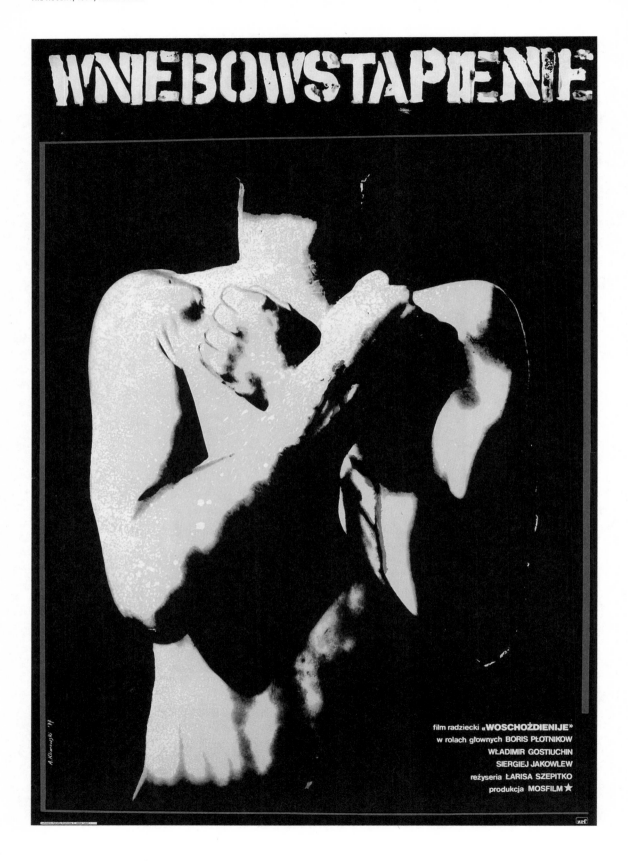

WNEBOWSTAPIENIE

film radziecki «WOSCHOŻDIENIJE»
w rolach głównych BORIS PŁOTNIKOW
WŁADIMIR GOSTIUCHIN
SIERGIEJ JAKOWLEW
reżyseria ŁARISA SZEPITKO
produkcja MOSFILM ★

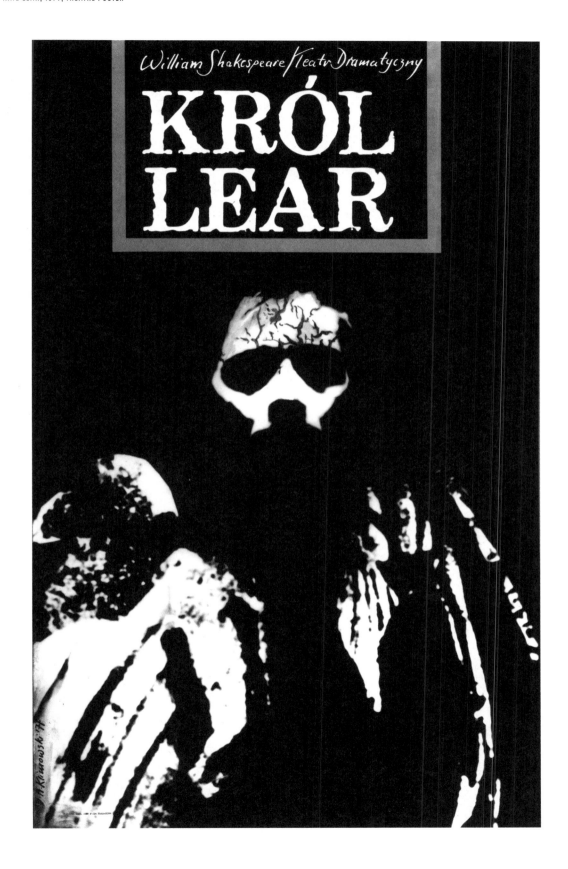

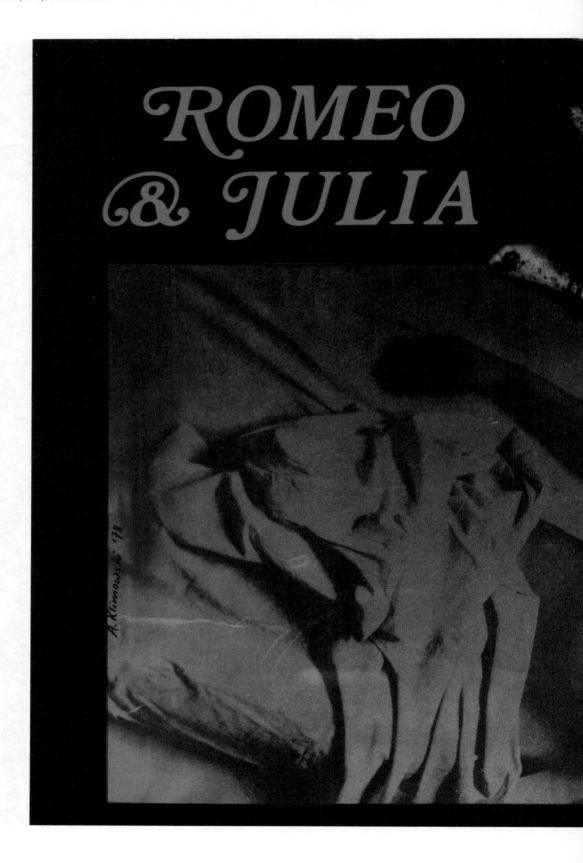

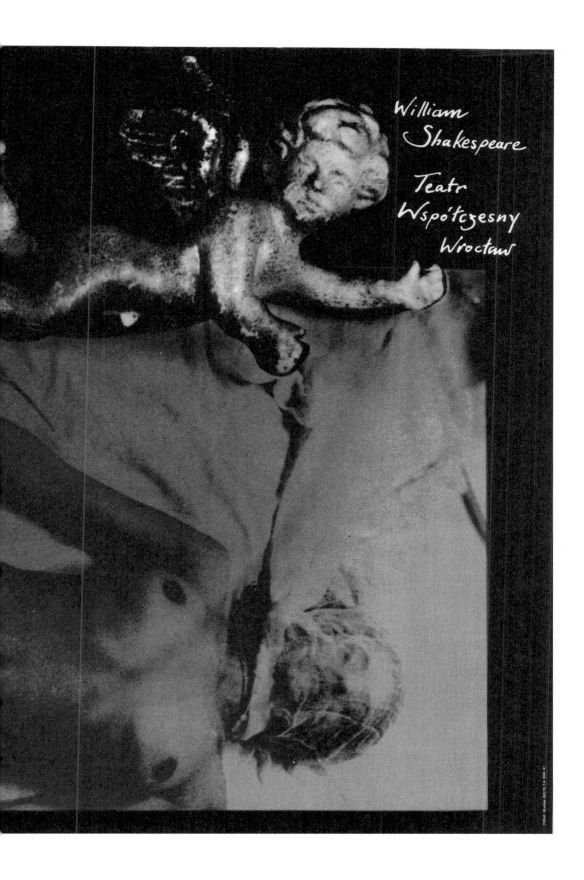

William
Shakespeare

Teatr
Współczesny
Wrocław

47

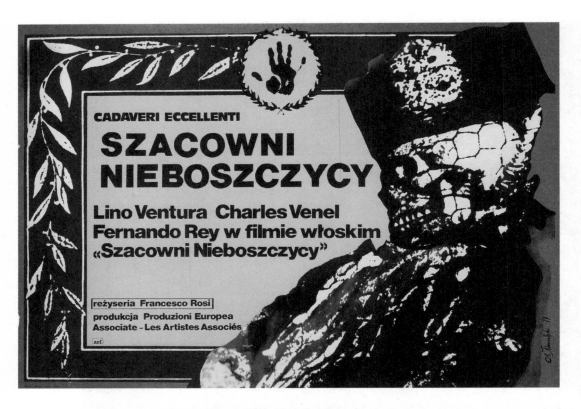

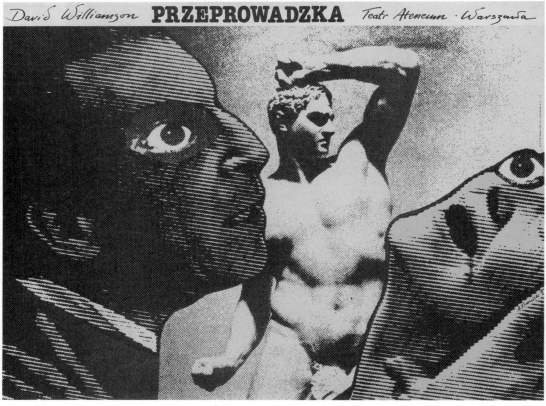

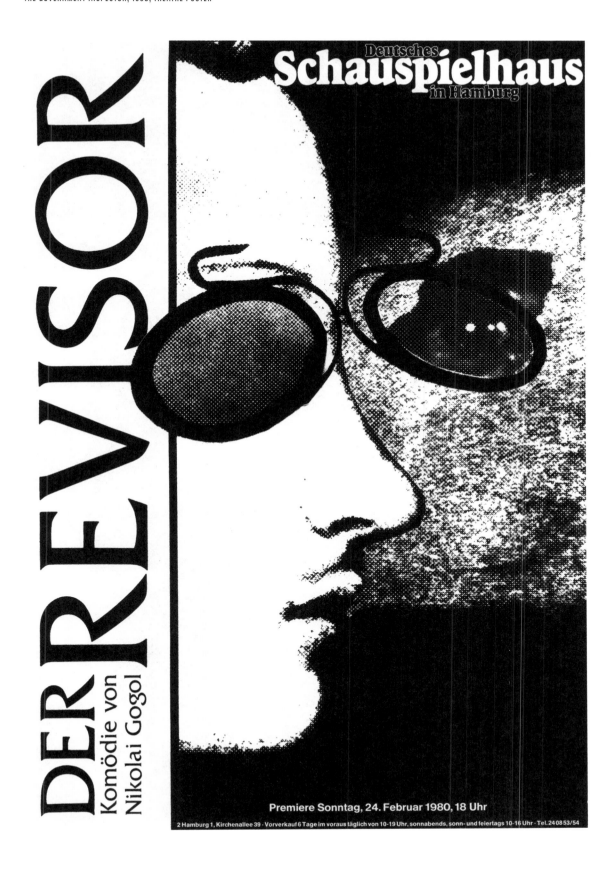

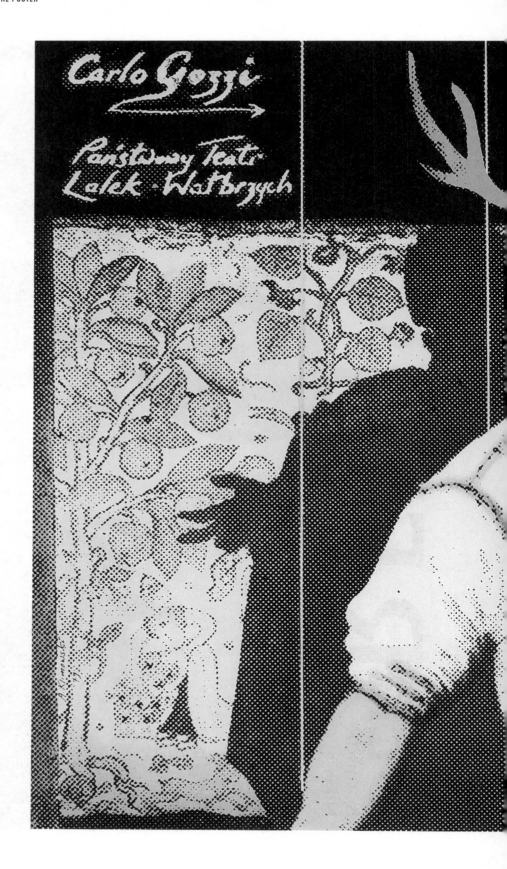

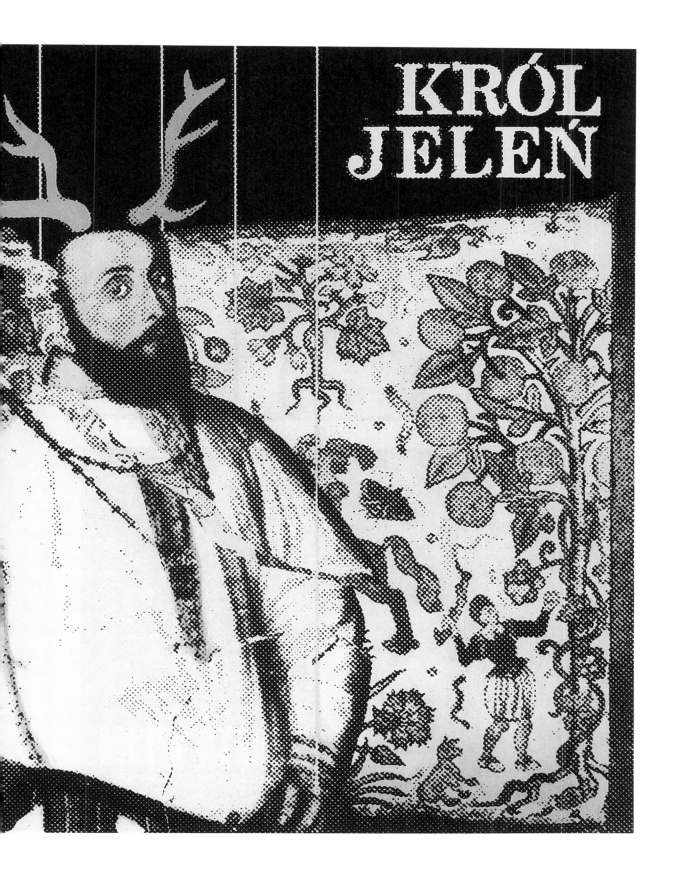

KRÓL JELEŃ

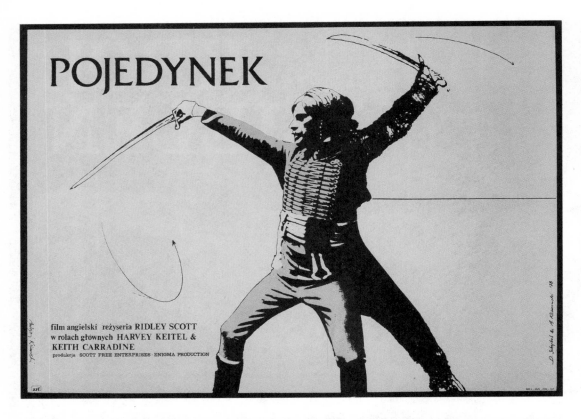

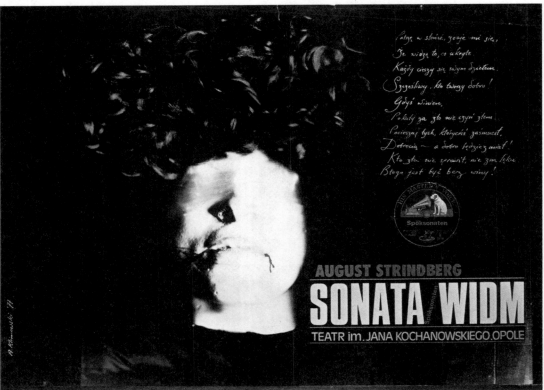

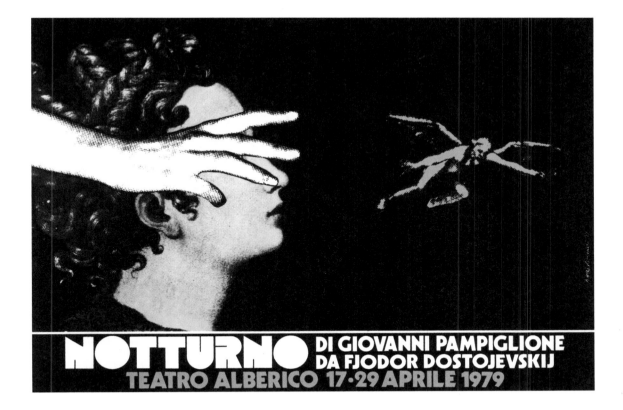

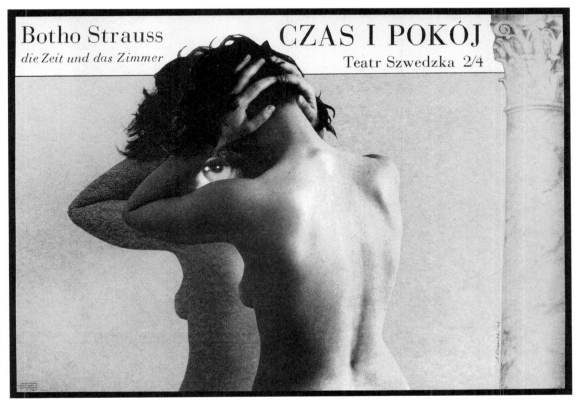

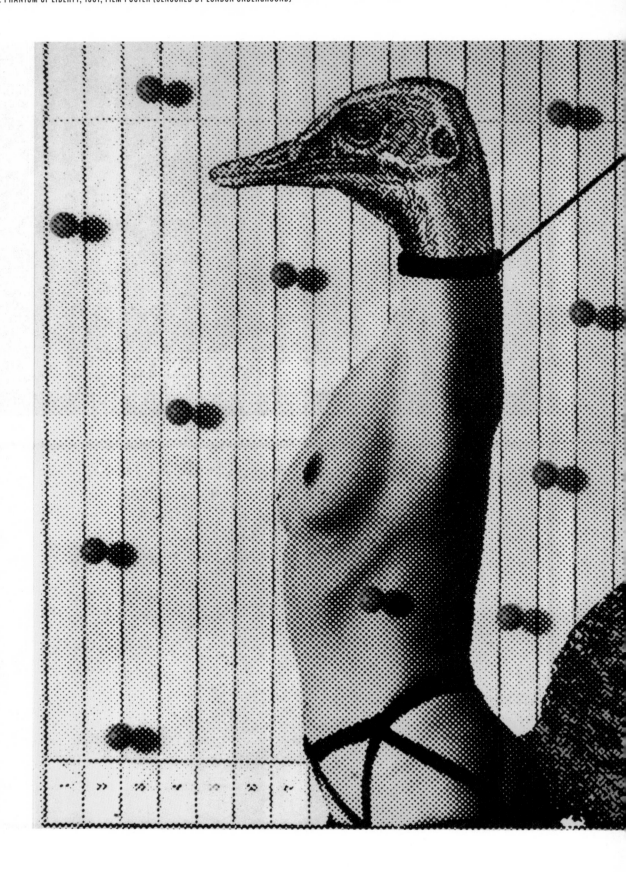

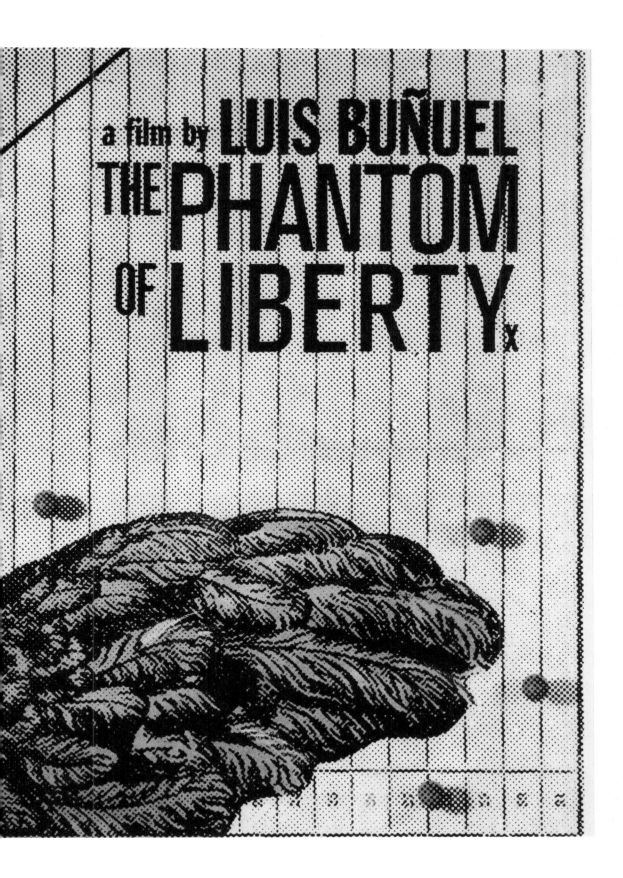

a film by LUIS BUÑUEL
THE PHANTOM
OF LIBERTY x

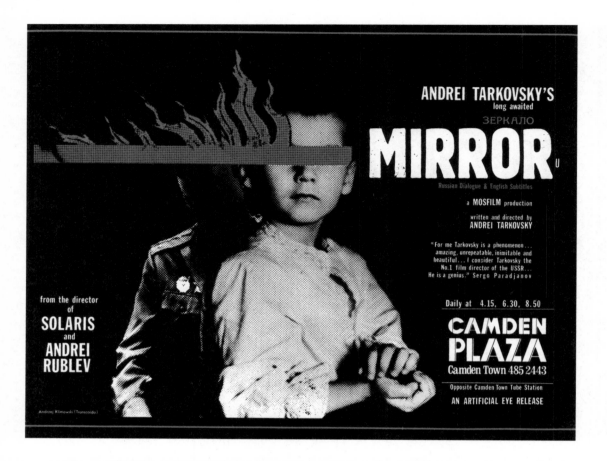

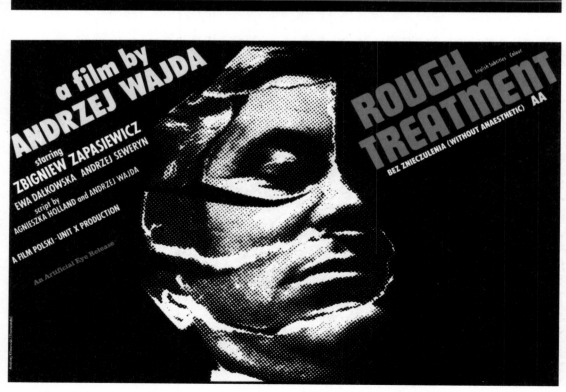

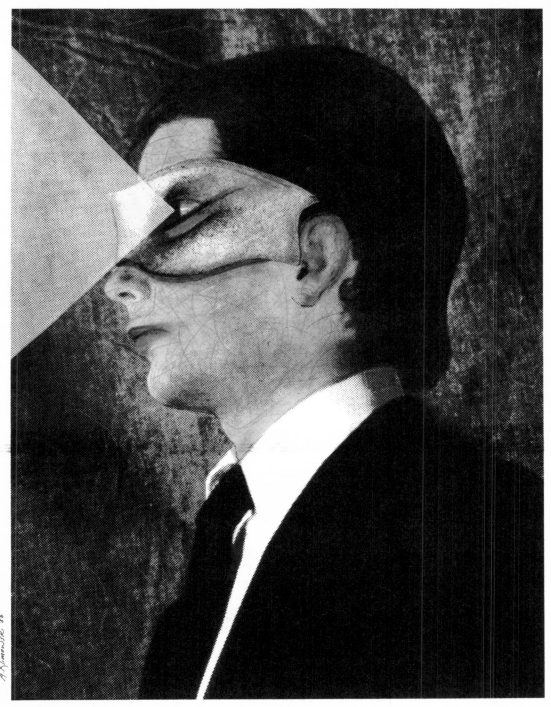

28 Ogólnopolski Festiwal Filmów Krótkometrażowych
28th Polish Short Film Festival
28 Общепольский Фестиваль Короткометражных Фильмов

28 Polnisches Kurzfilmfestival
28-e Festival Polonais du Film de Court Metrage
KRAKÓW 28.V.–31.V.1988

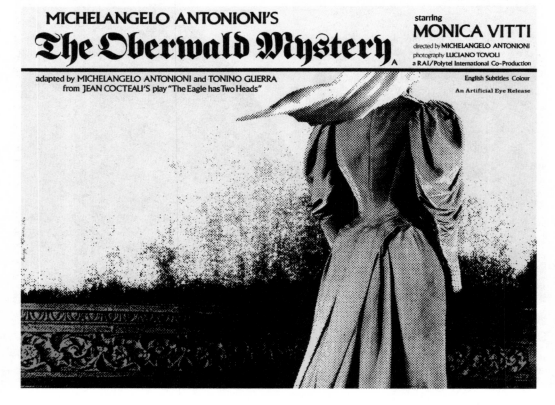

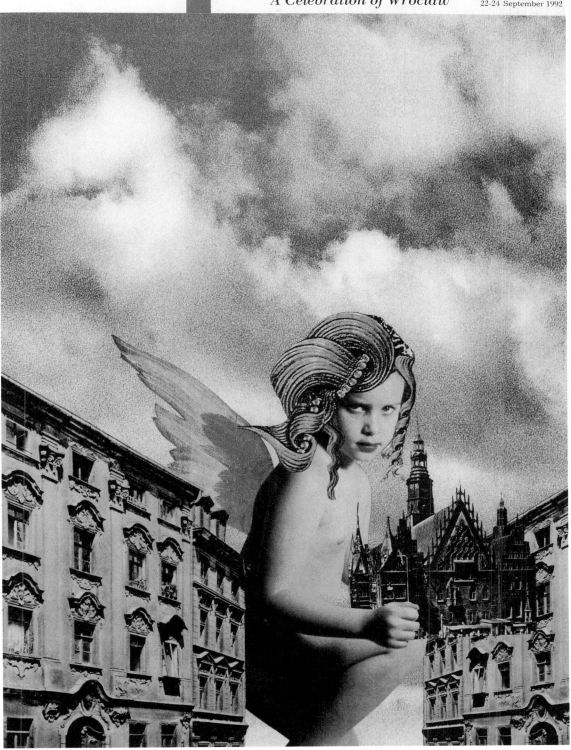

Expo 92 Sevilla

DNI WROCŁAWIA
A Celebration of Wrocław

22-24 September 1992

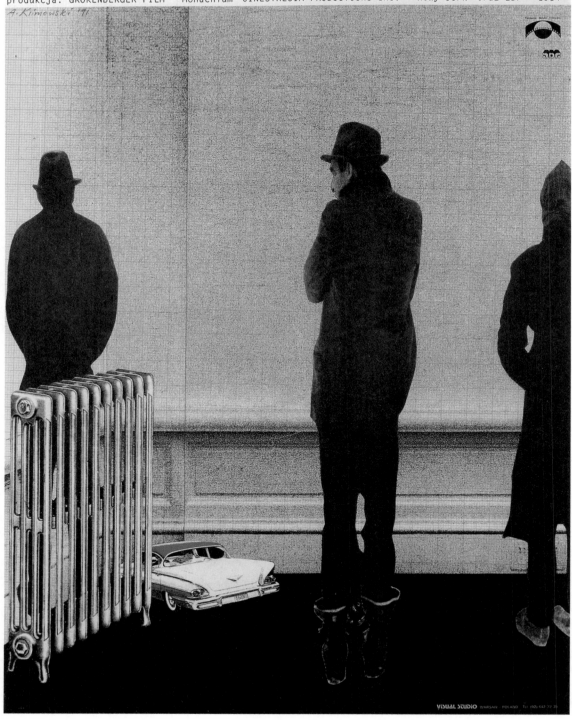

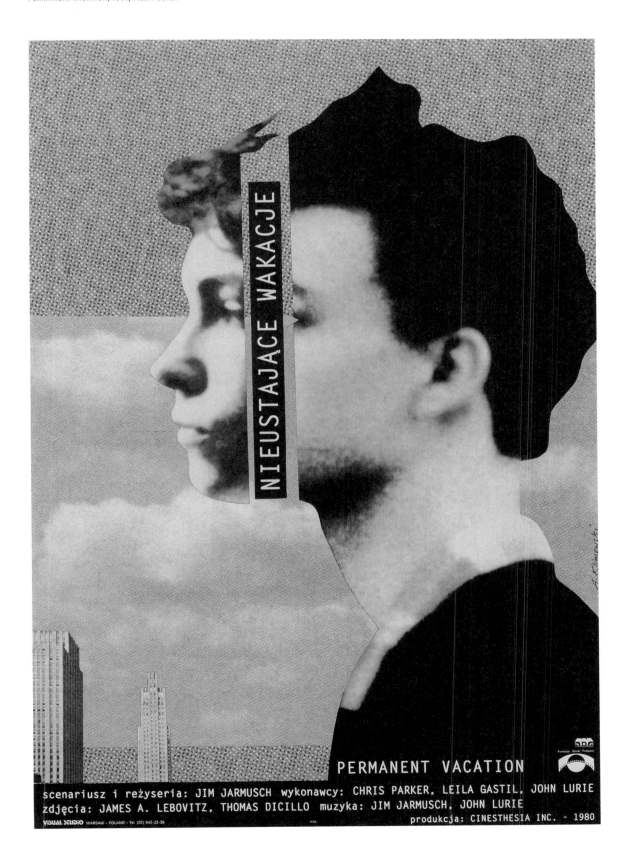

NIEUSTAJĄCE WAKACJE

PERMANENT VACATION

scenariusz i reżyseria: JIM JARMUSCH wykonawcy: CHRIS PARKER, LEILA GASTIL, JOHN LURIE
zdjęcia: JAMES A. LEBOVITZ, THOMAS DICILLO muzyka: JIM JARMUSCH, JOHN LURIE
produkcja: CINESTHESIA INC. - 1980

VISUAL STUDIO WARSAW - POLAND - Tel. (02) 642-22-36

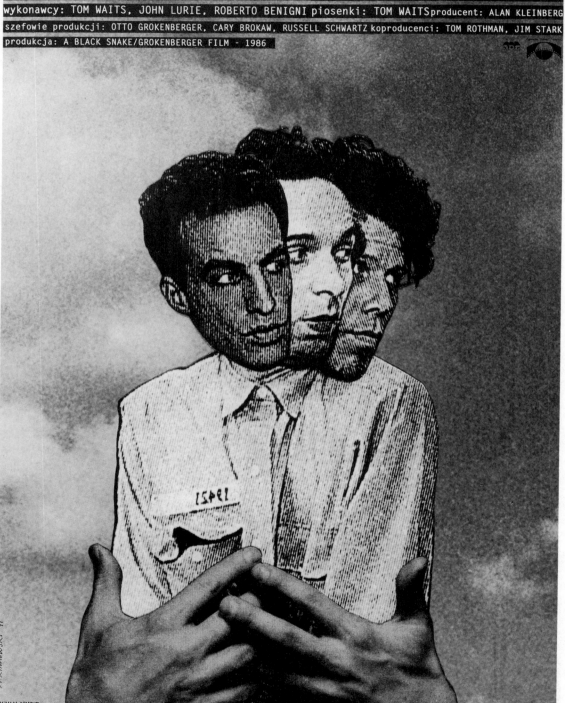

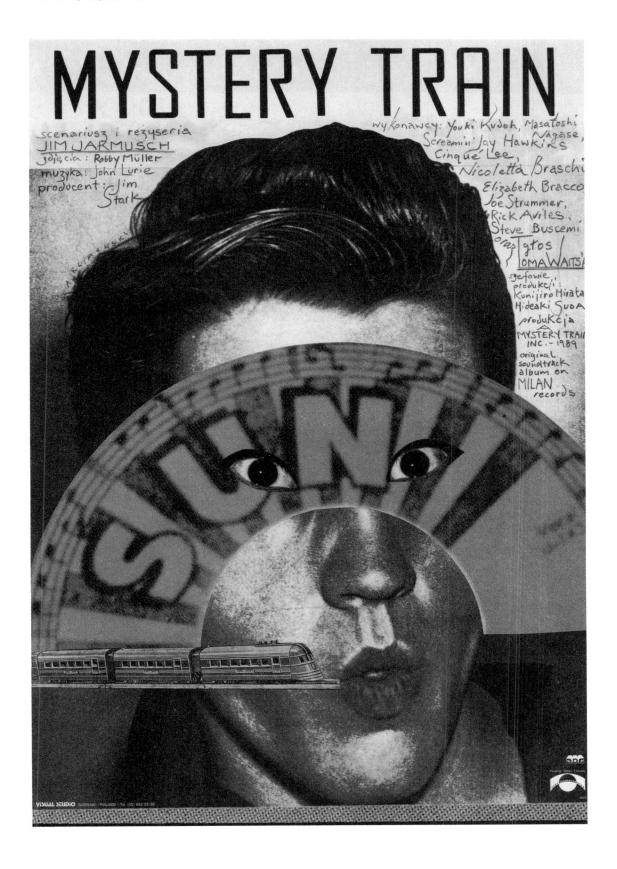

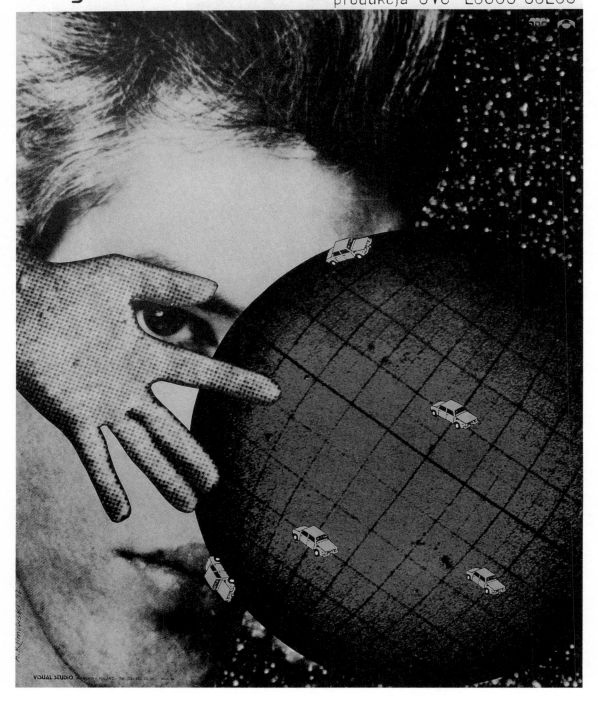

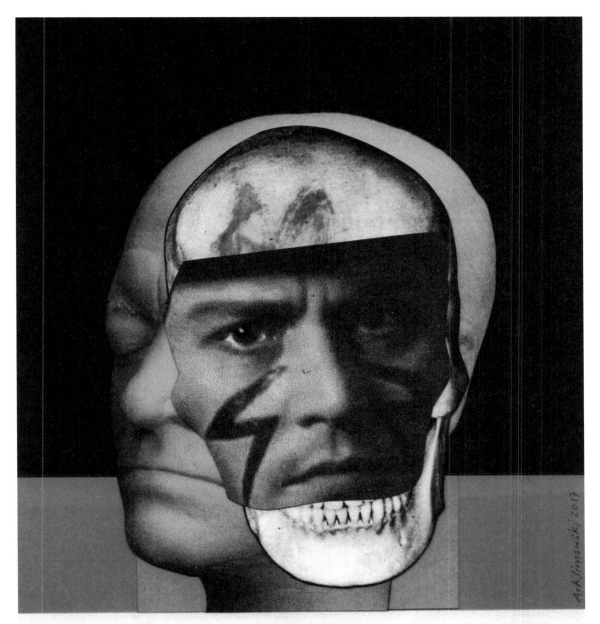

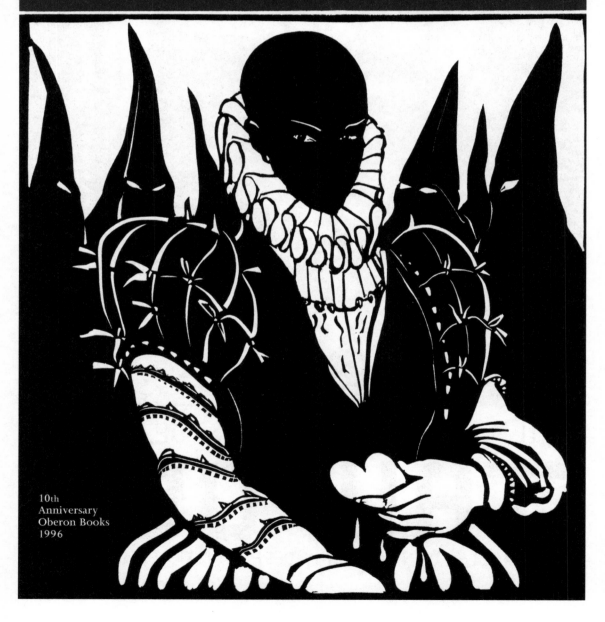

SCHILLER
DON CARLOS
translated by Robert David MacDonald

10th
Anniversary
Oberon Books
1996

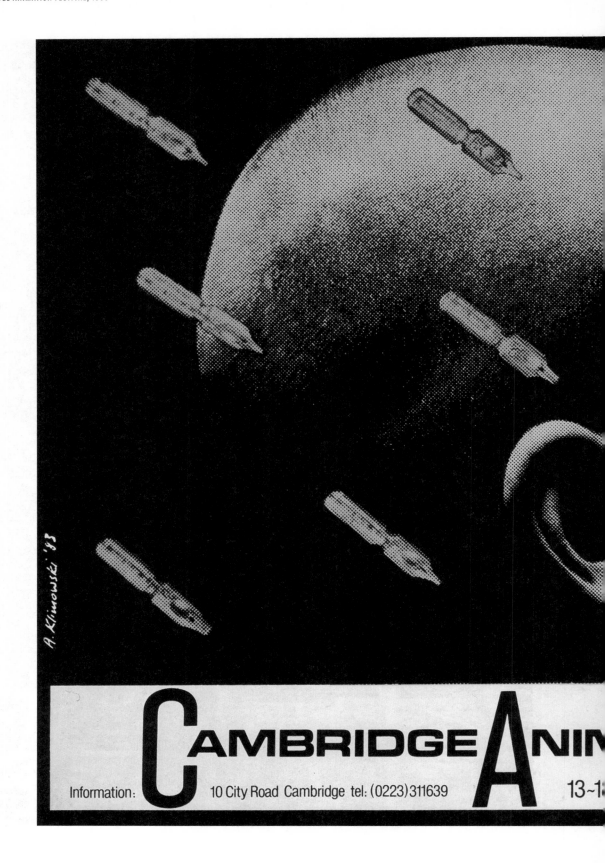

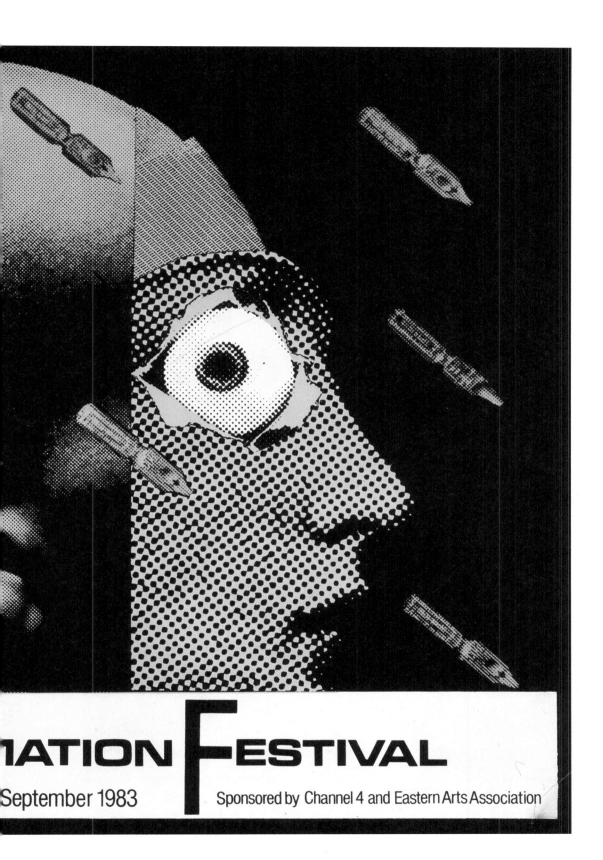

IATION FESTIVAL

September 1983 Sponsored by Channel 4 and Eastern Arts Association

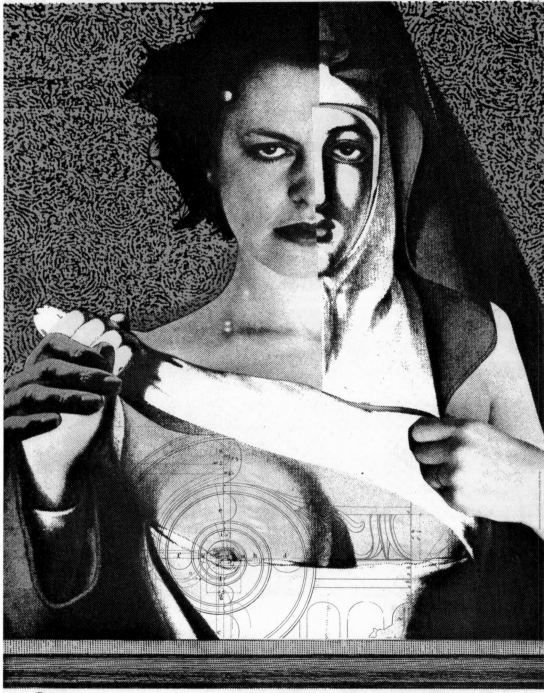

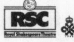

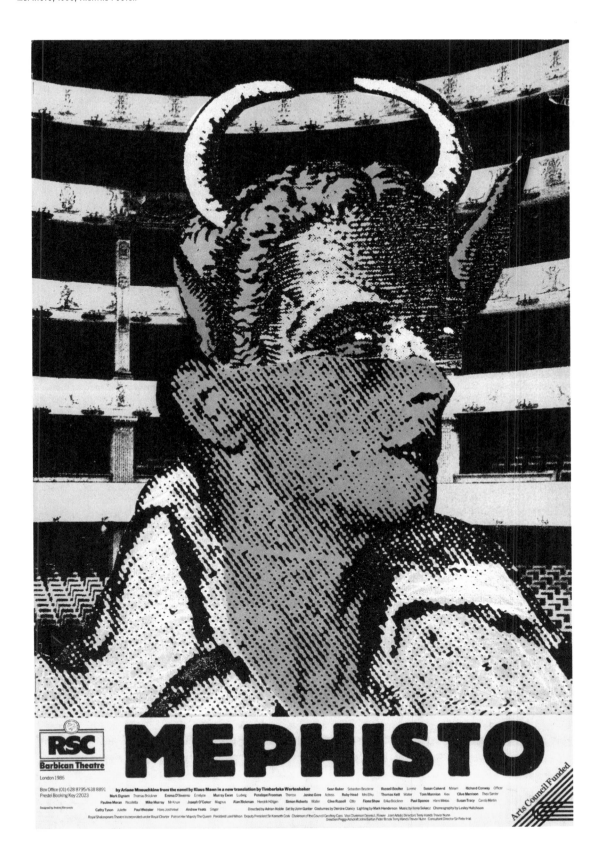

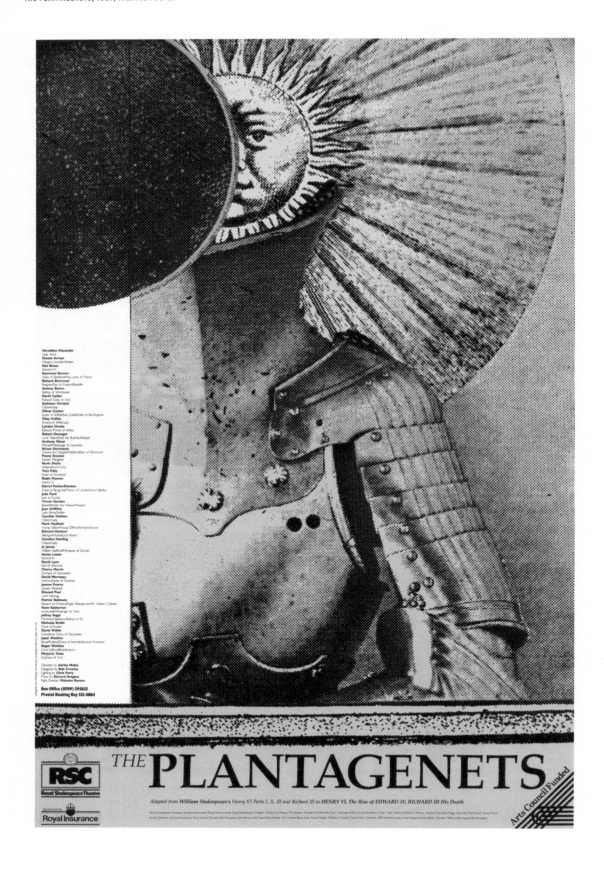

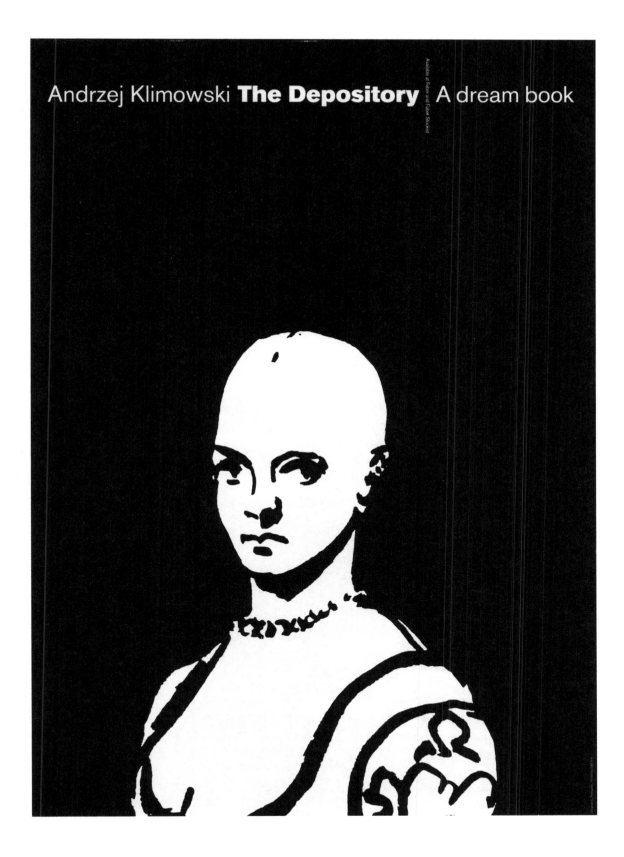

Andrzej Klimowski **The Depository** A dream book

Available at Faber and Faber Stockist

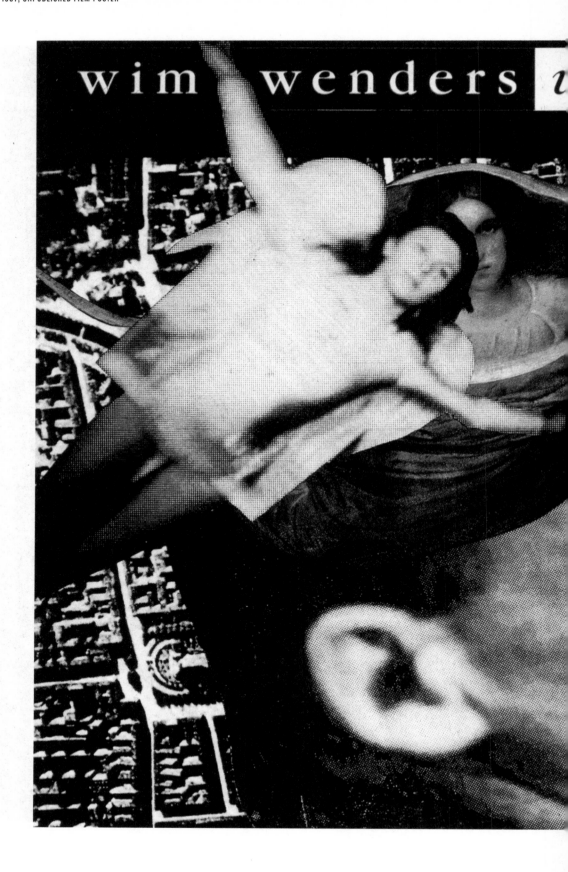

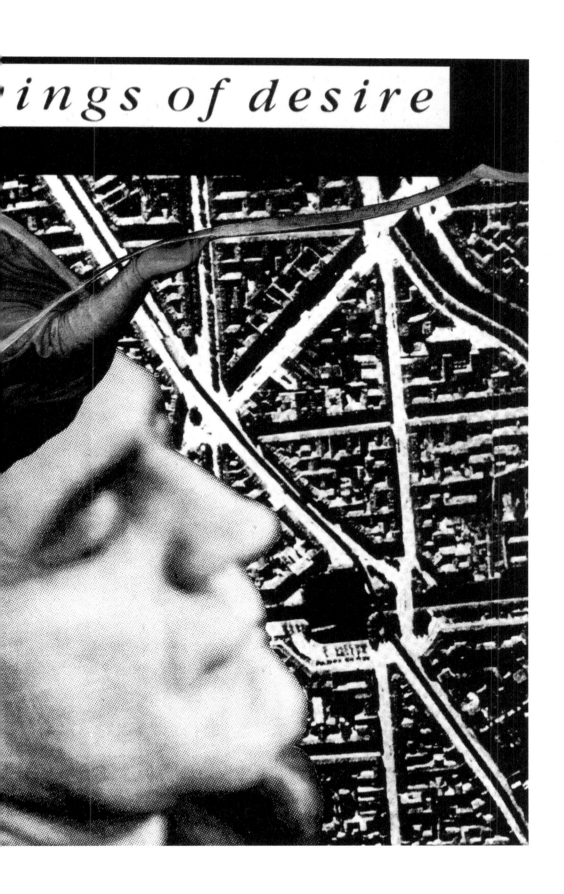

rings of desire

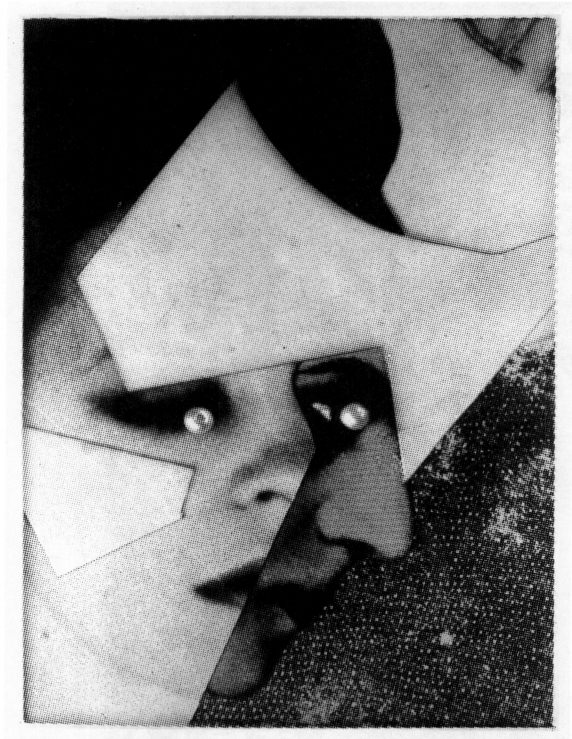

THRASHING DOVES

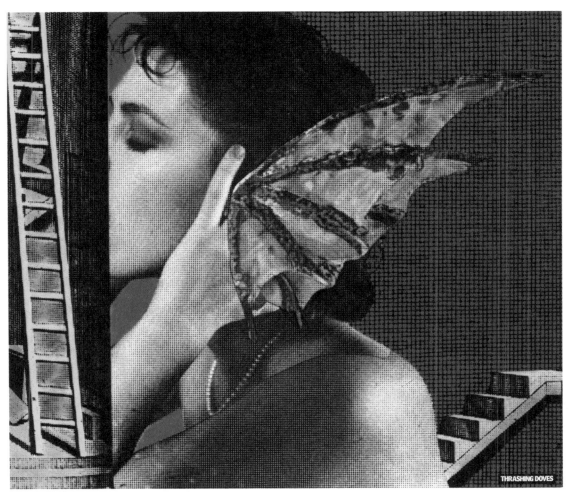

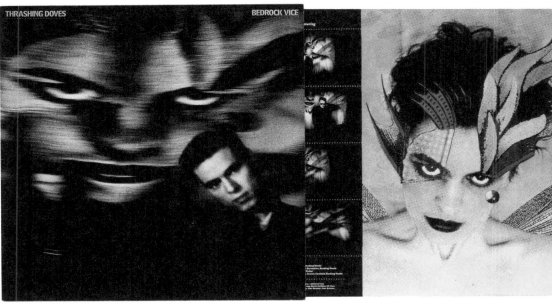

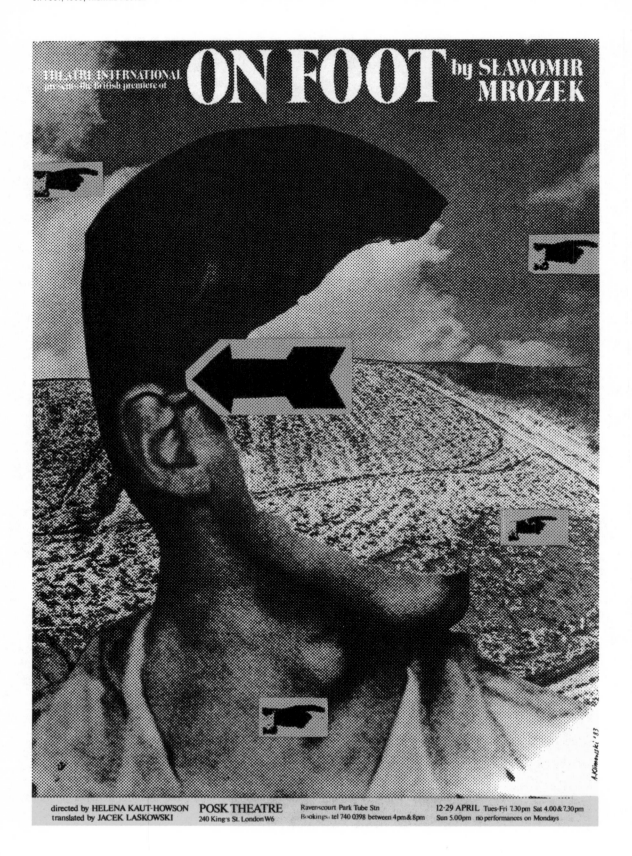

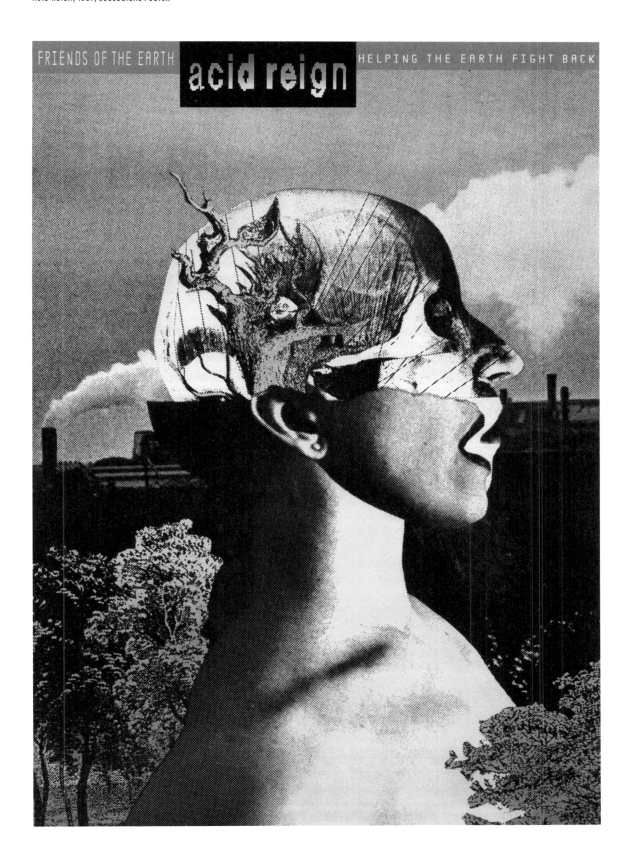

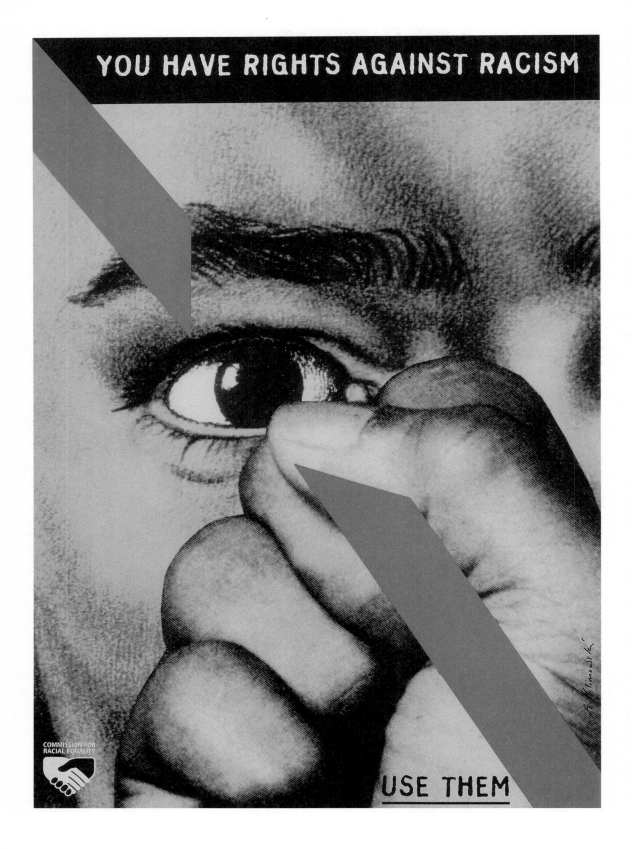

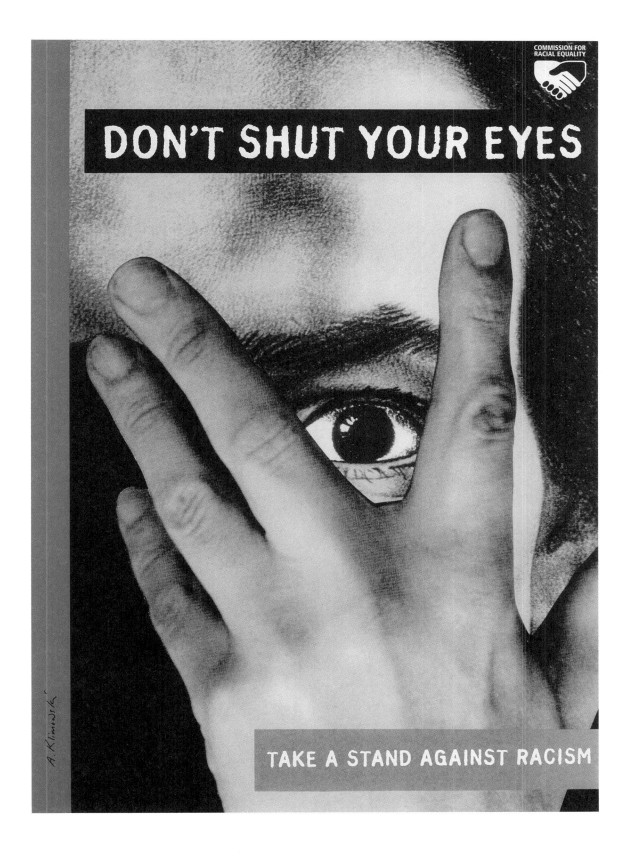

FINE ART
at Oxford Brookes University
B A HONOURS

Fine Art at Oxford Brookes University

This newly established and distinctive Fine Art course provides an opportunity to develop individual creative practice as an artist across a wide range of disciplines within the University's Modular Course.

Its interdisciplinary character enables students to ally traditional skills and approaches in Drawing, Painting and Printmaking to those emerging from new technologies, allowing opportunities for innovative and distinctive developments in Bookworks, Photography and Time-based Media which are rooted in a clearly formulated basis of theory.

Further information is obtainable from the Field Chair in Fine Art, School of Visual Arts, Music & Publishing, Oxford Brookes University, Headington, Oxford OX3 0BP.
Tel. (0865) 483461/8

NB Fine Art is also offered in combination with another academic subject. Further information on this course is also available.

OXFORD BROOKES UNIVERSITY

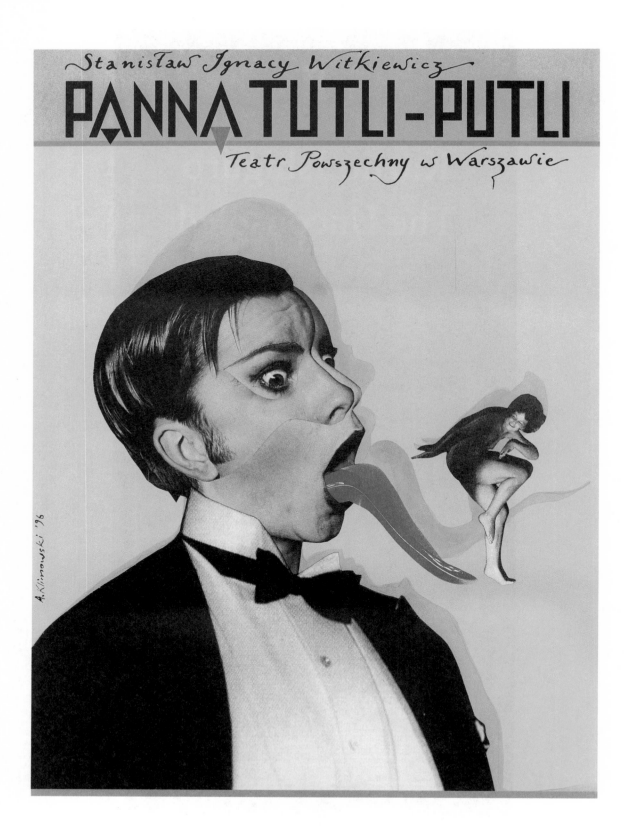

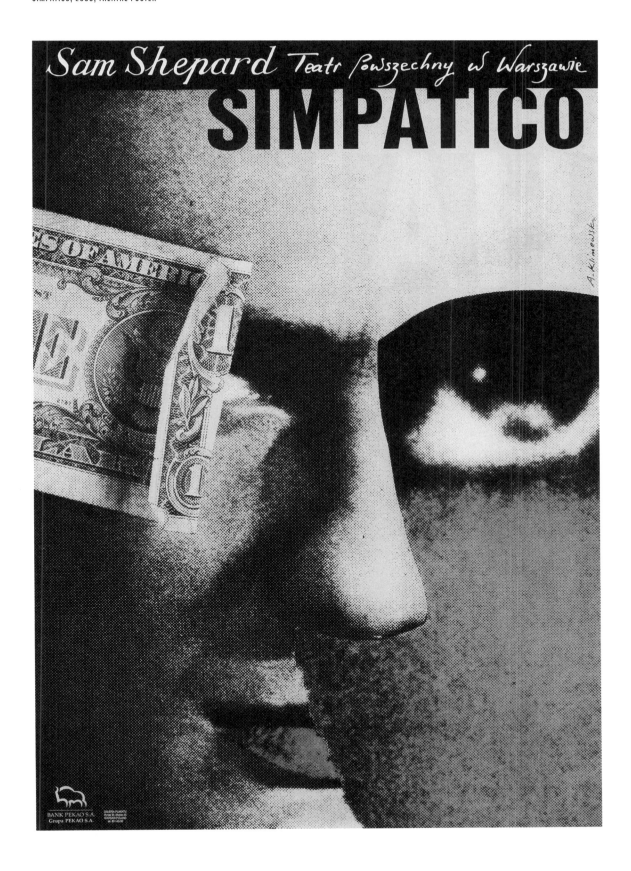

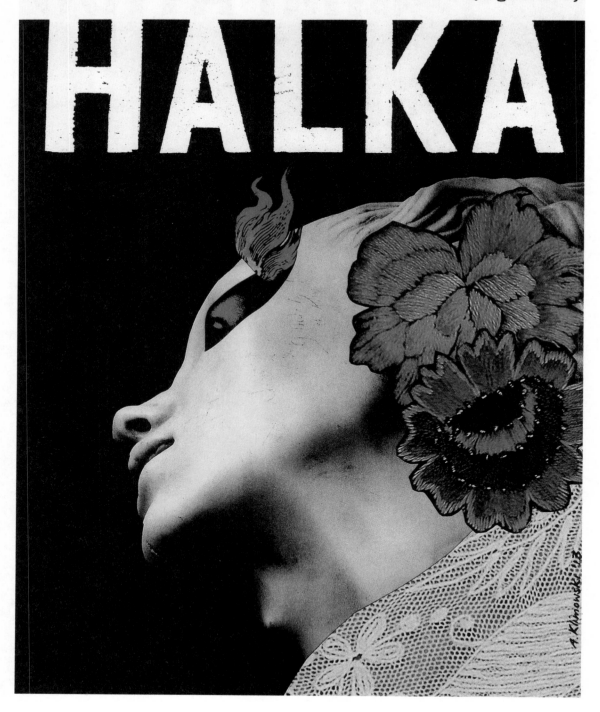

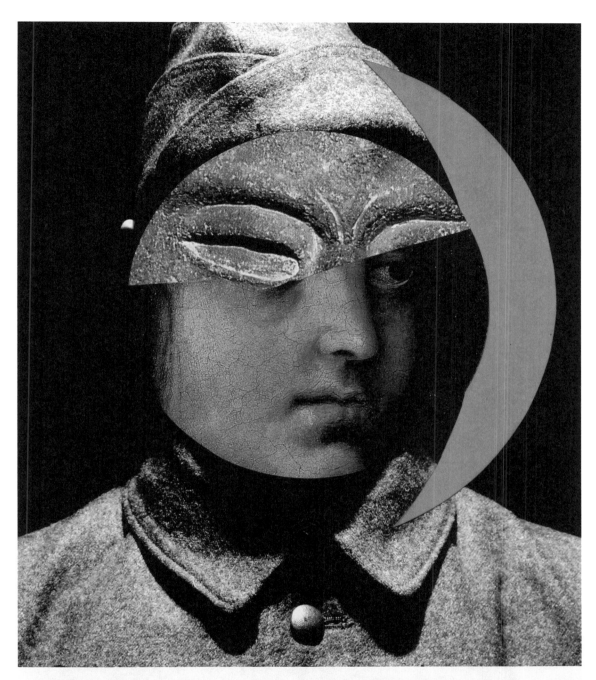

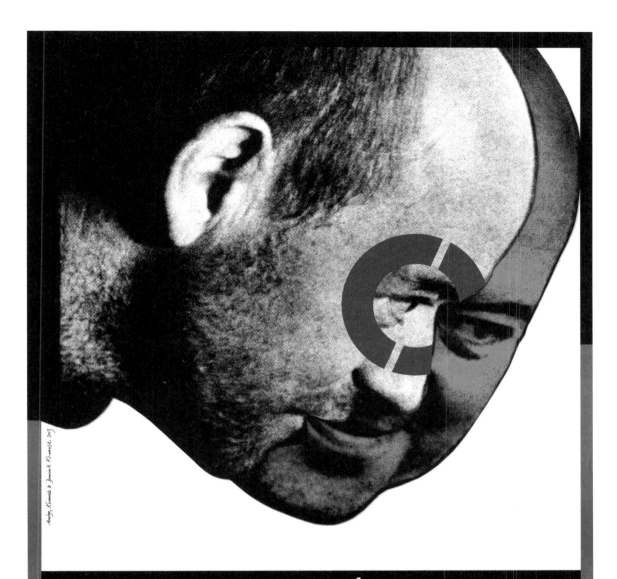

2013

World Chess
Championship
Candidates

L. Aronian (ARM)
M. Carlsen (NOR)
B. Gelfand (ISR)
A. Grischuk (RUS)
V. Ivanchuk (UKR)
V. Kramnik (RUS)
T. Radjabov (AZE)
P. Svidler (RUS)

World Chess
London
Candidates
Tournament

The Final Eliminator for the 2013
World Chess Championship Match

The Institution
of Engineering
& Technology

15 March – 1 April, 2013

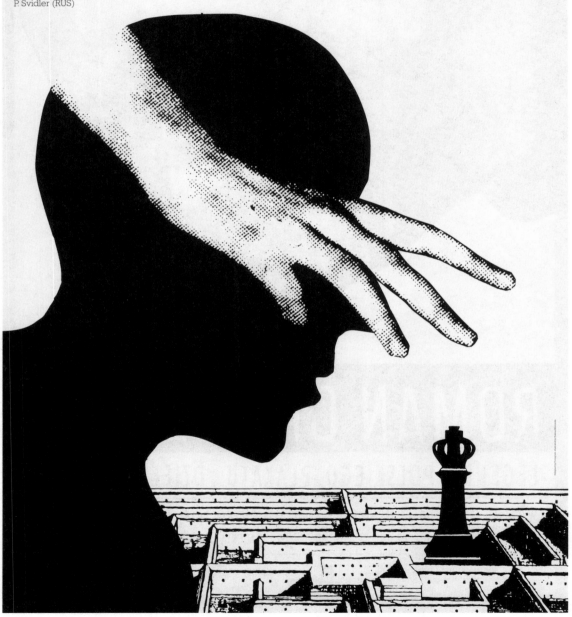

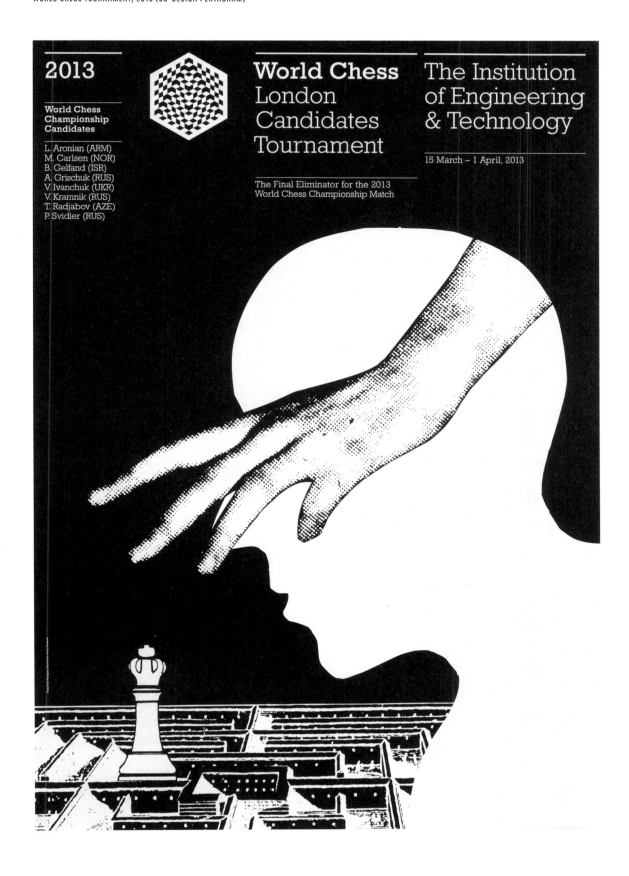

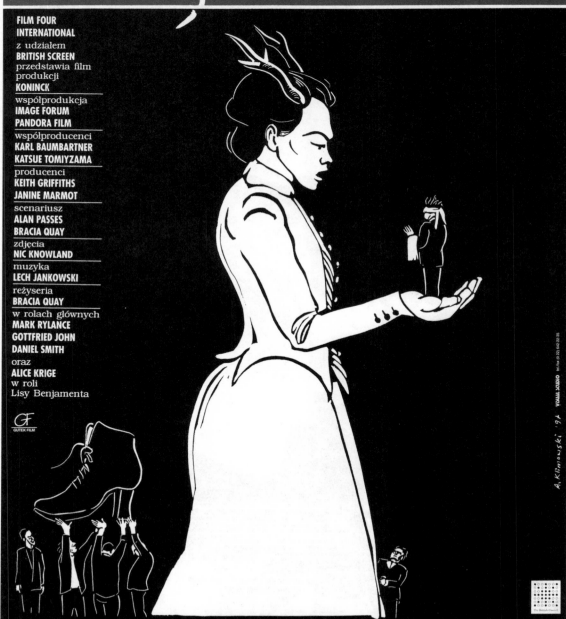

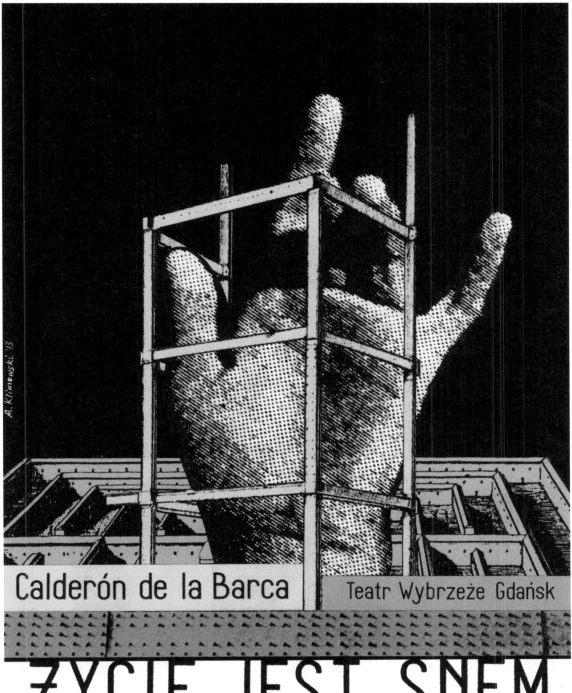

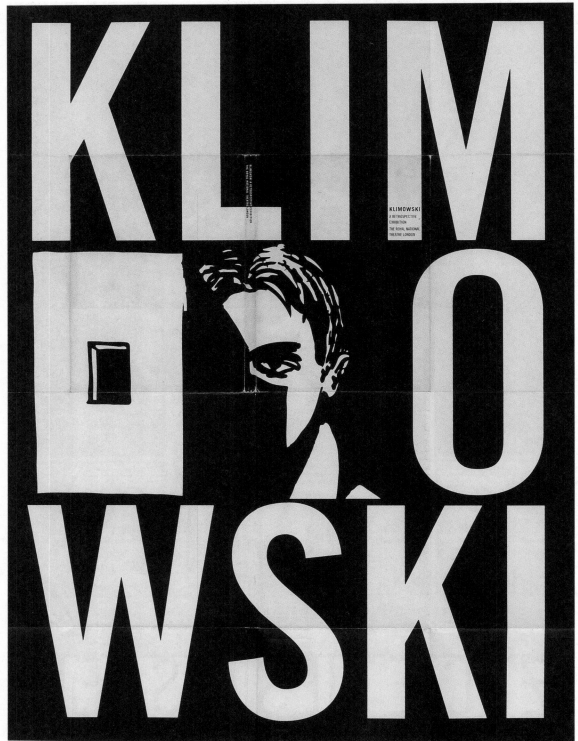

ZWYCZAJNA
HISTORIA

MUNDANE
HISTORY

SCENARIUSZ I REŻYSERIA ANOCHA SUWICHAKORNPONG WYKONAWCY PHAKPOOM SURAPONGSANURUK, ARKANEY CHERKHAM ZDJECIA MING KAI LEUNG
SCENOGRAFIA PARINDA MOONGMAIPHOL MUZYKA THE PHOTO STICKER MACHINE, FURNITURE KOOPRODUKCJA I MONTAŻ LEE CHATAMETIKOOL
PRODUKCJA SOROS SUKHUM, ANOCHA SUWICHAKORNPONG DYSTRYBUCJA W POLSCE STOWARZYSZENIE NOWE HORYZONTY

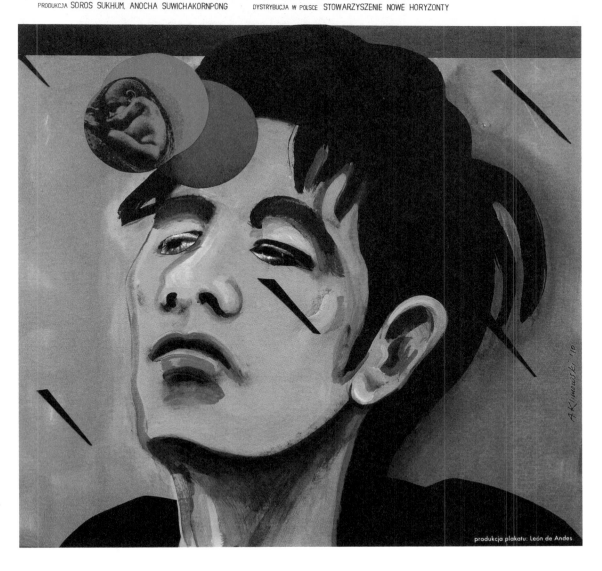

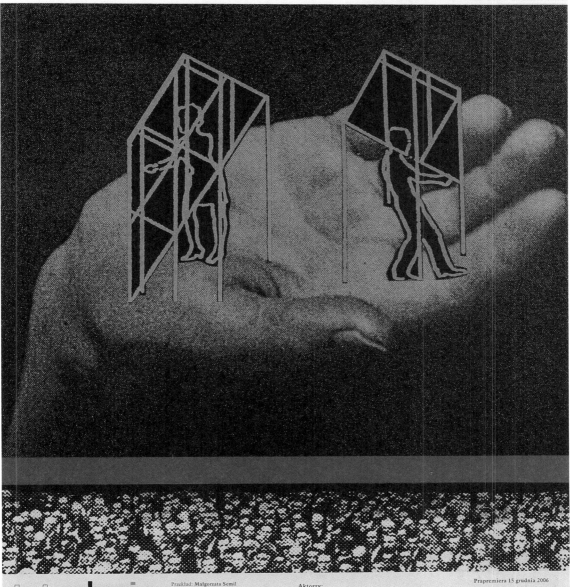

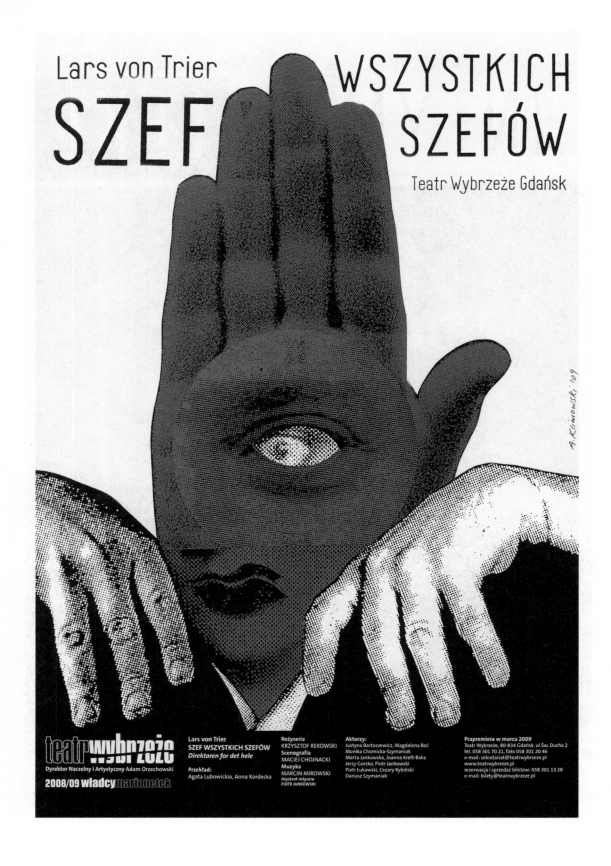

Frank Wedekind Teatr Powszechny Warszawa

Przebudzenie Wiosny

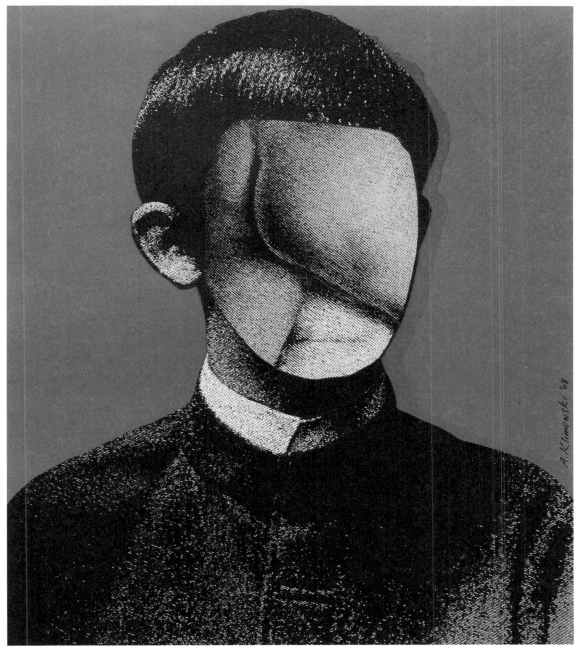

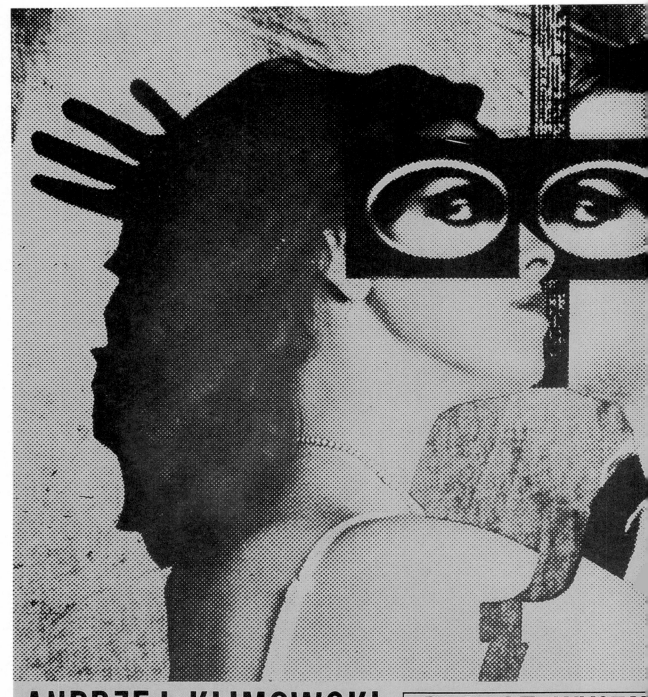

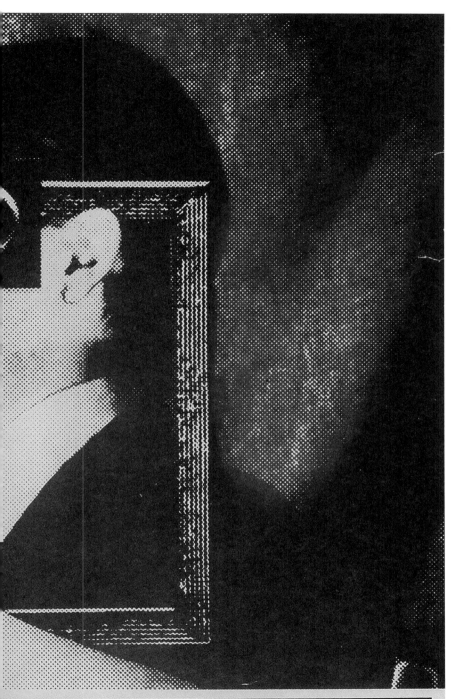

WA Z KOLEKCJI KRZYSZTOFA DYDO

Opole · Pl. Lenina · luty/marzec 1985

D N I
THEMERSONÓW
W WARSZAWIE

21-23
Listopad

CZWARTEK 21.11
O rekonstrukcjach filmów Themersonów
Warsztaty ze stołem trikowym
Prowadzanie: Bruce Checefsky
Gdzie: Instytut Teatralny, ul. Jazdów 1
Godzina: 11.00 – 13.00

**Dyskusja panelowa: Twórczość Themersonów
połączona z prezentacją themersonowskiego
numeru "Literatury na Świecie"**
Gdzie: Instytut Teatralny, ul. Jazdów 1
Godzina: 17.00

**Otwarcie wystawy: "Franciszka Themerson.
Ludzie i Kreski, rysunki z lat 50 i 60 XX wieku"**
Wprowadzenie: Nick Wadley
Gdzie: Instytut Teatralny, ul. Jazdów 1
Godzina: 18.00

**Blok filmowy: Filmy Themersonów
i film dokumentalny „Franciszka i Stefan"
w reż. Tomasza Poboga-Malinowskiego.
Po projekcji spotkanie z reżyserem.**
Prowadzenie: Marcin Giżycki
Gdzie: Sala kinowa w Muzeum Narodowym,
al. Jerezolimskie 3
Godzina: 20.15

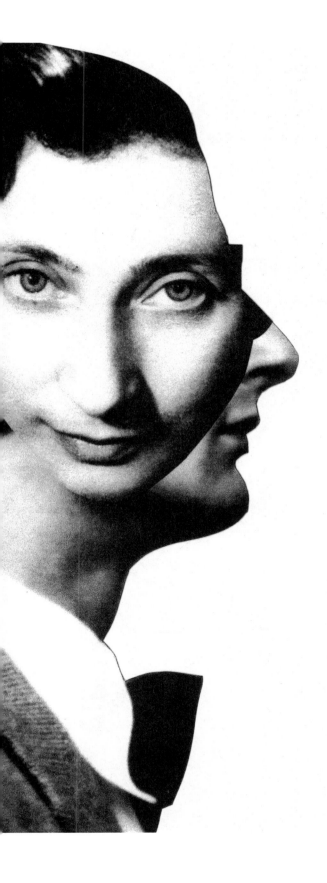

22.11 PIĄTEK
Warsztaty ze stołem trikowym
Prowadzanie: Bruce Checefsky
Gdzie: Instytut Teatralny, ul. Jazdów 1
Godzina: 11.00 – 13.00

**Blok filmowy: Film średniometrażowy
"Stefan Themerson & język"
Spotkanie z reżyserem
filmu Erikiem van Zuylenem**
Prowadzenie: Małgorzata Sady
Gdzie: Sala kinowa w Muzeum Narodowym,
al. Jerozolimskie 3
Godzina: 18.00

23.11 SOBOTA
Warsztaty ze stołem trikowym
Prowadzanie: Bruce Checefsky
Gdzie: Instytut Teatralny, ul. Jazdów 1
Godzina: 11.00 – 13.00

**Rozmowa o książce "Unposted Letters" (2013)
pod red. Jasi Reichardt, współpraca Nick Wadley**
Prowadzenie: Małgorzata Sady
Gdzie: Sala kinowa w Muzeum Narodowym,
al. Jerozolimskie 3
Godzina: 17.00

**Prezentacja nowych wydań książek
Themersonów (2013) z udziałem wydawców**
Godzina: 19.15
**Blok filmowy: Film długometrażowy
"The Mystery of the Sardine"
w reż. Erika van Zuylena
wg powieści Stefana Themersona**
Słowo wstępne: Małgorzata Sady
Gdzie: Sala kinowa w Muzeum Narodowym,
al. Jerozolimskie 3
Godzina: 19.15

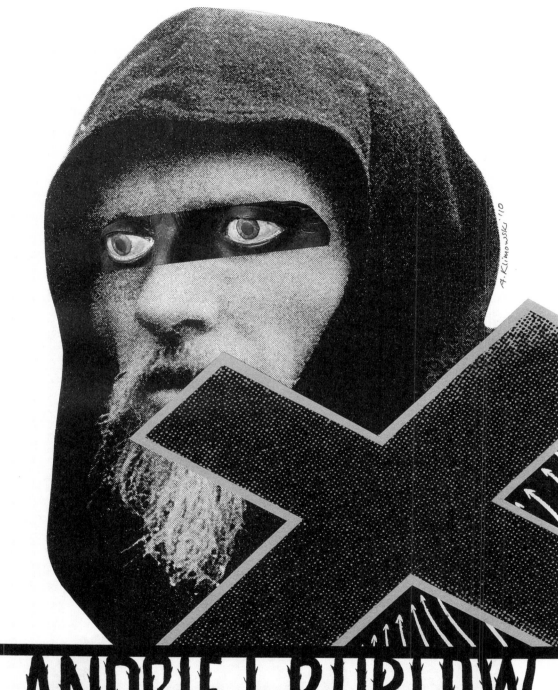

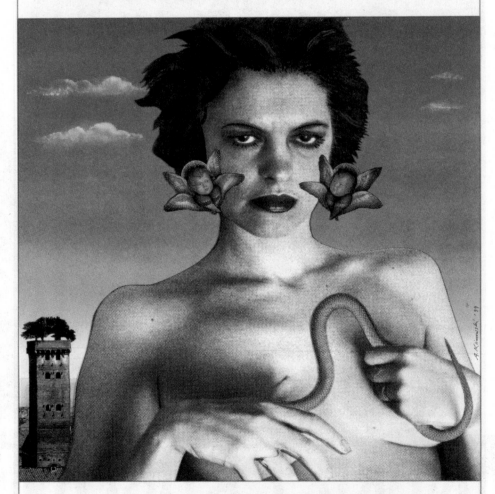

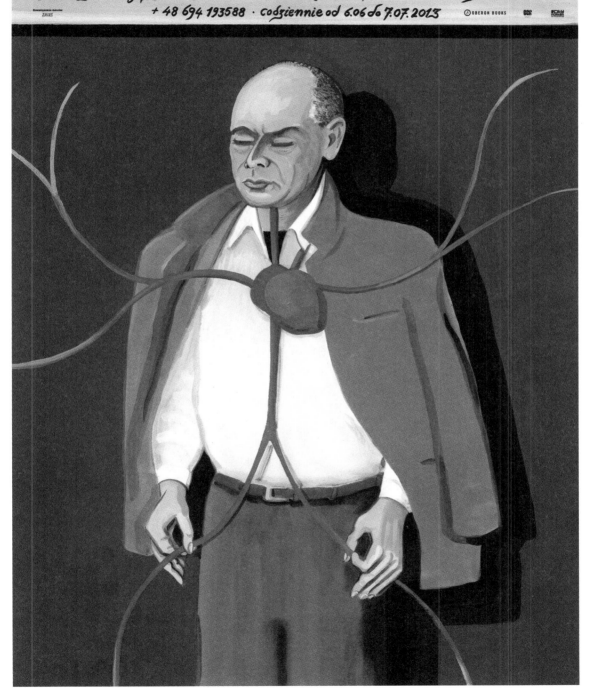

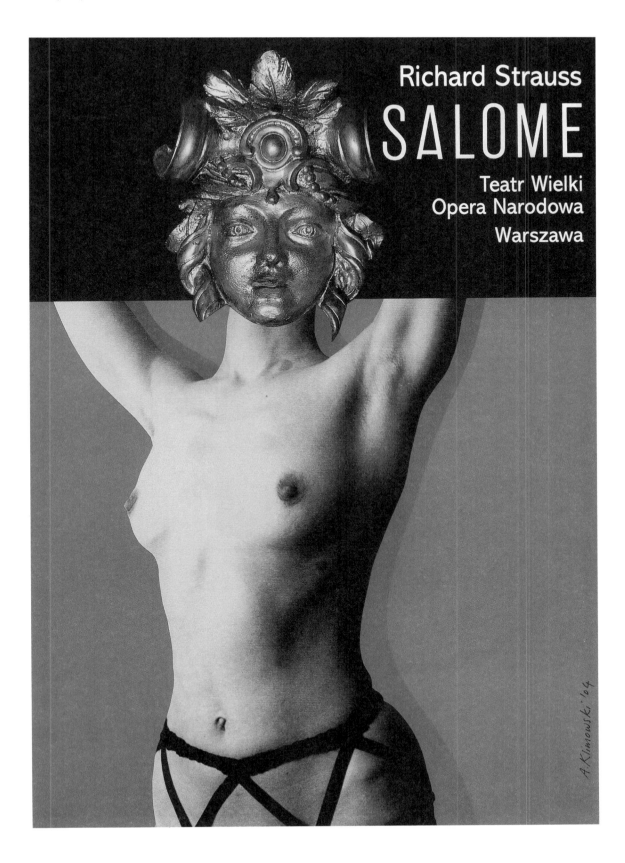

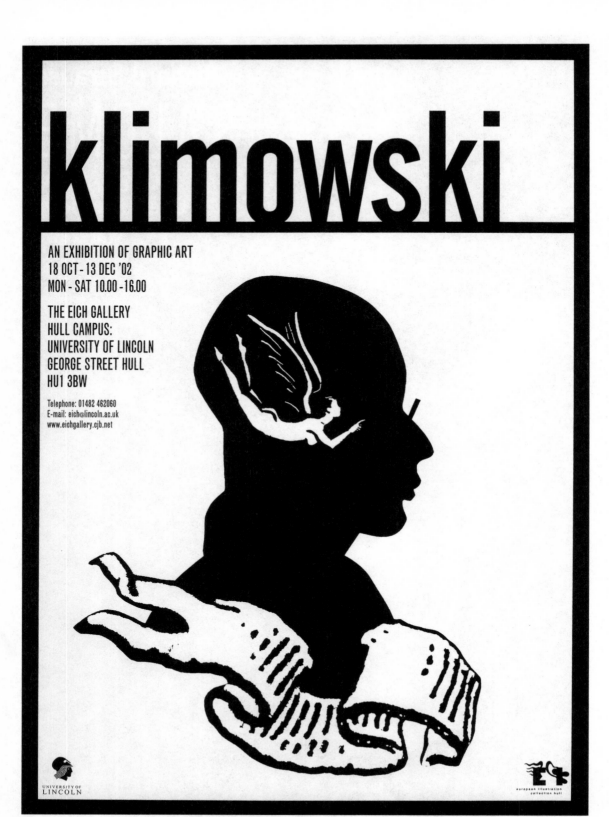

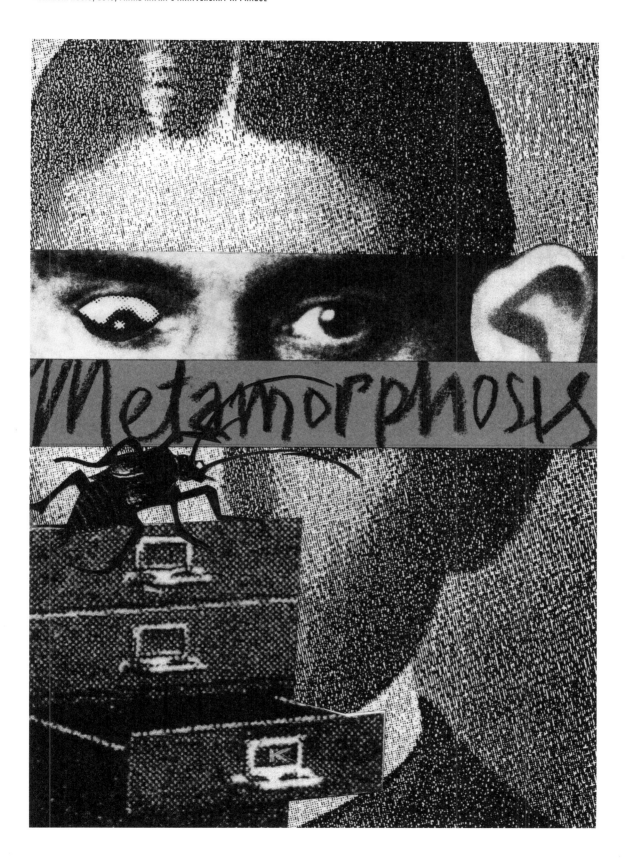

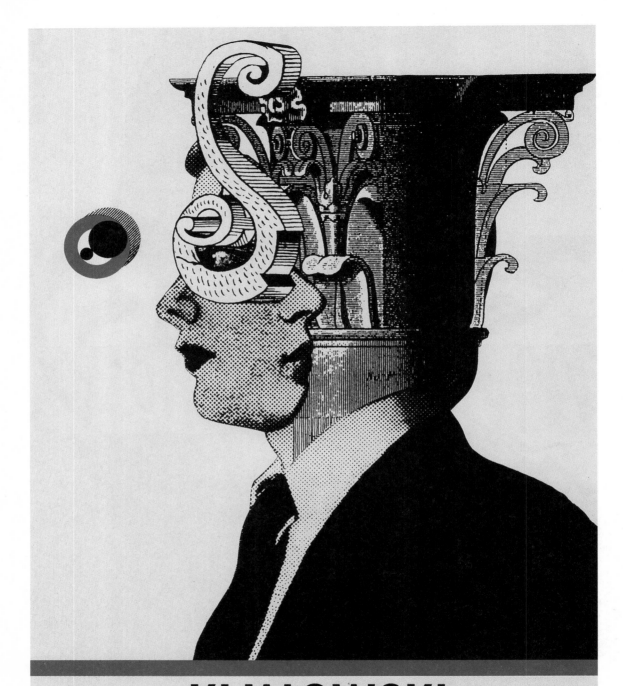

Andrzej **KLIMOWSKI** Londyn

Więcej niż plakat / More Than The Poster Edycja 2006 Wystawa zorganizowana w ramach przeglądu działań artystycznych „Wokół Cieślewicza" Galeria Miejska "Arsenał", Poznań, 19.02 – 12.03. 2006 Powiatowa Galeria Sztuki Współczesnej, Ostrów Wielkopolski, 7.07. – 30.07. 2006

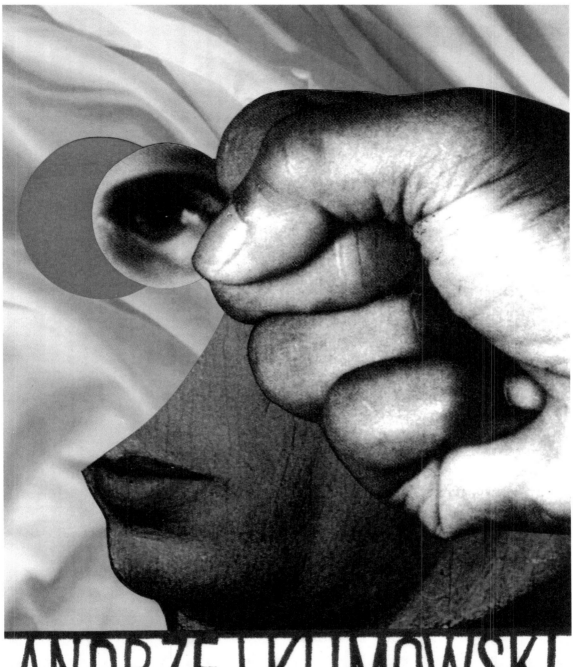

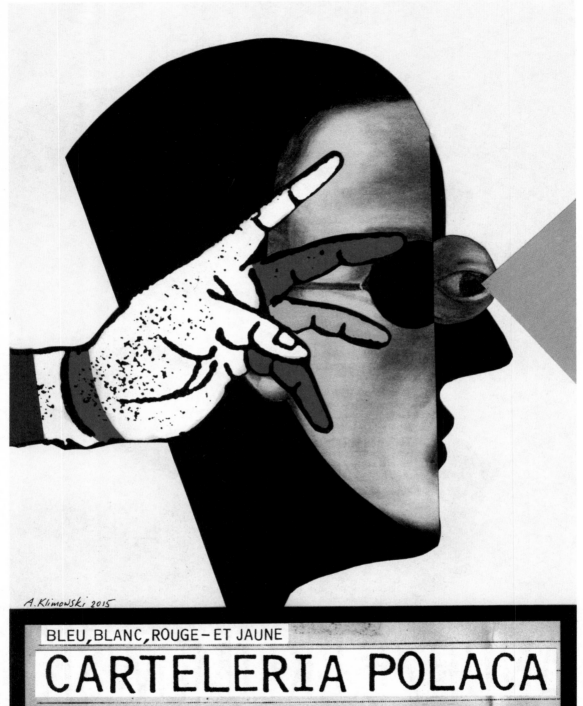

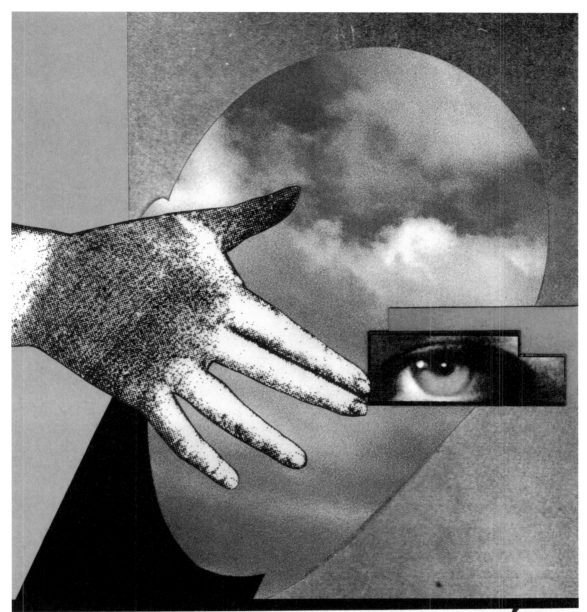

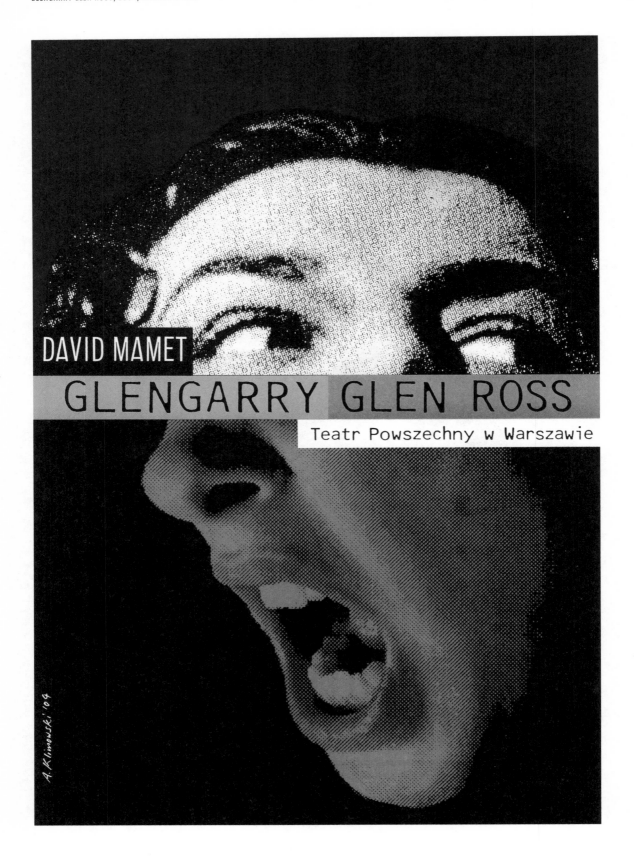

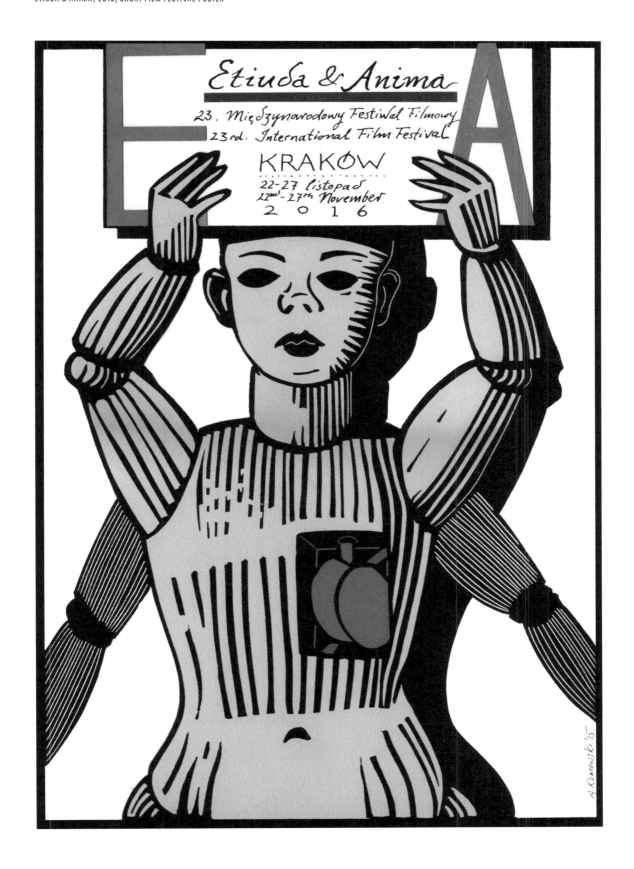

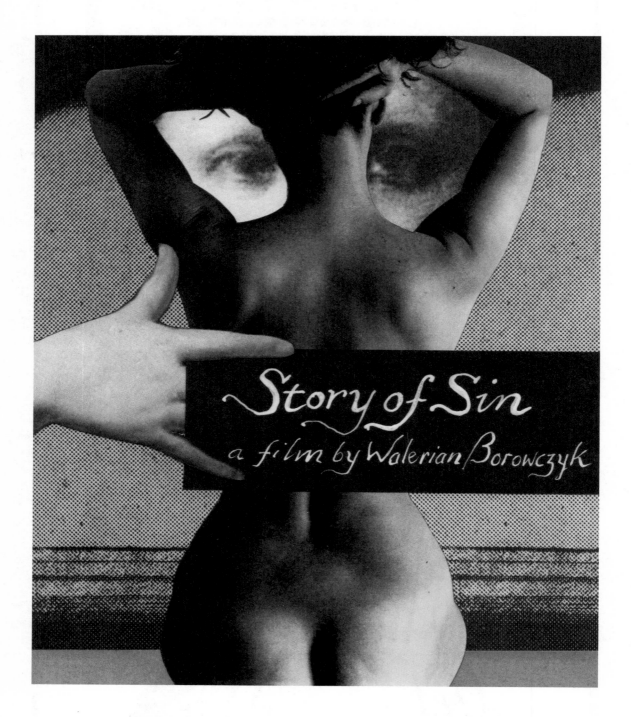

HARD TO BE A GOD A FILM BY ALEKSEI GERMAN

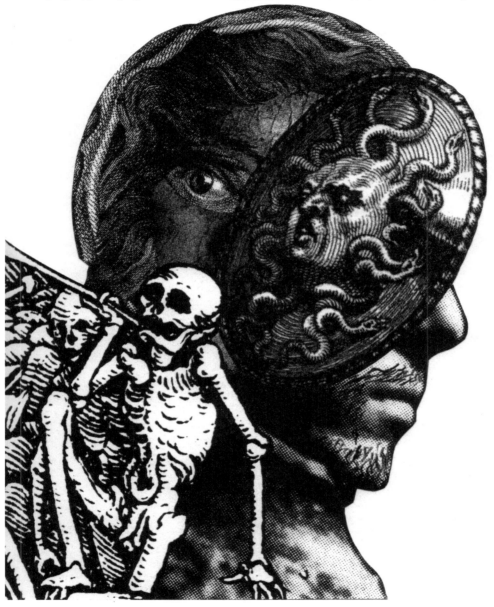

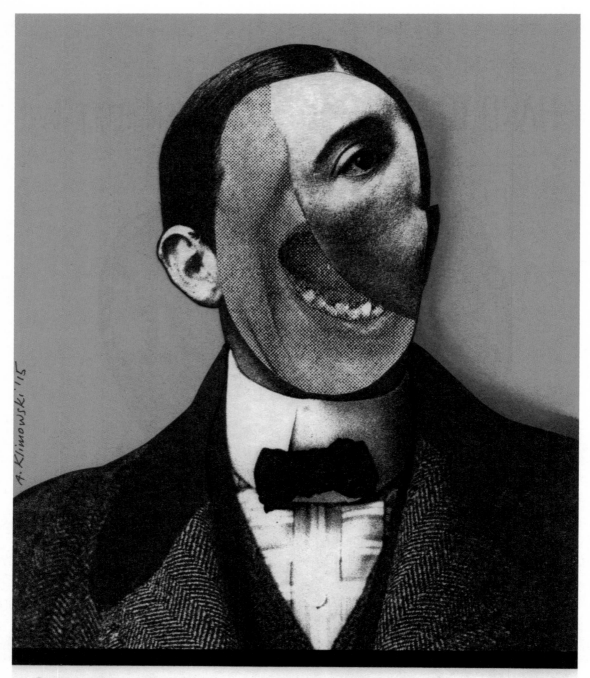

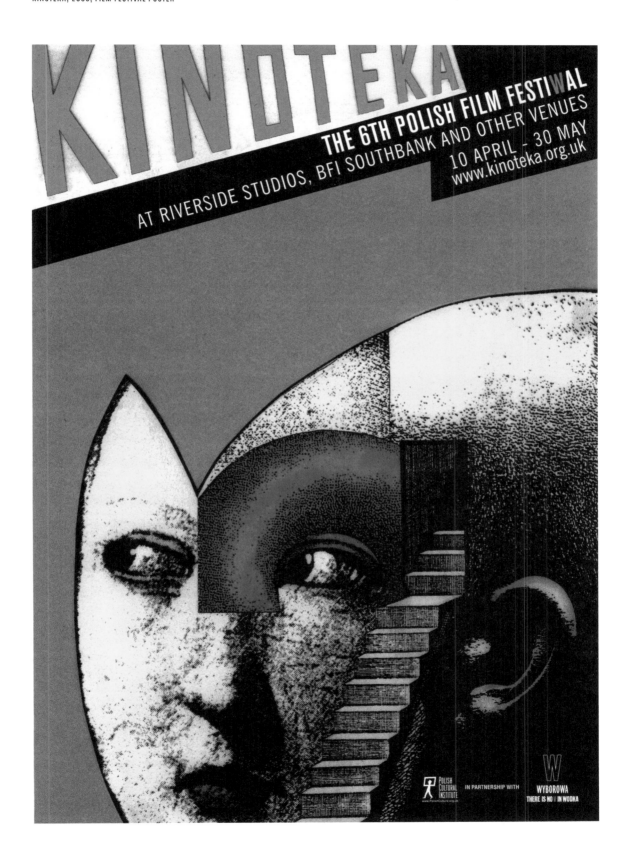

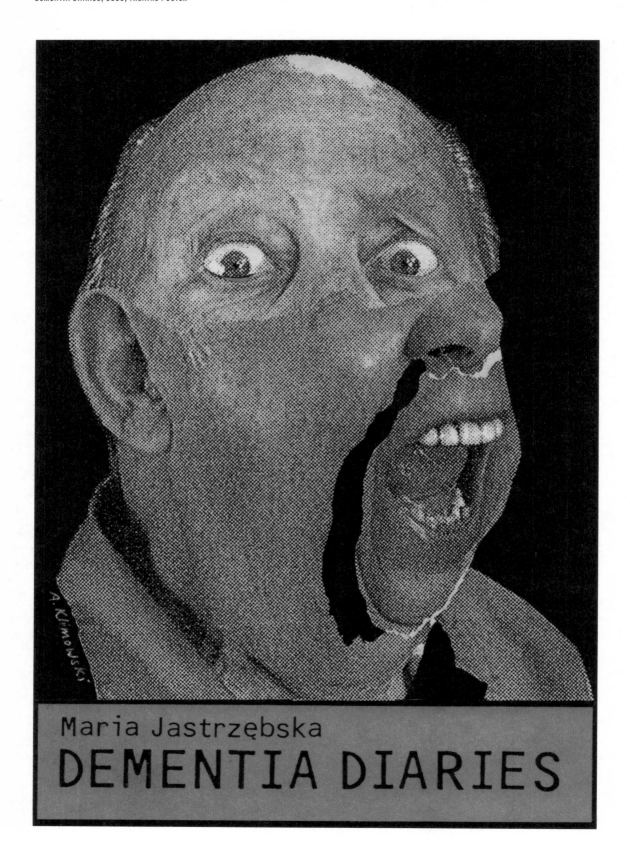

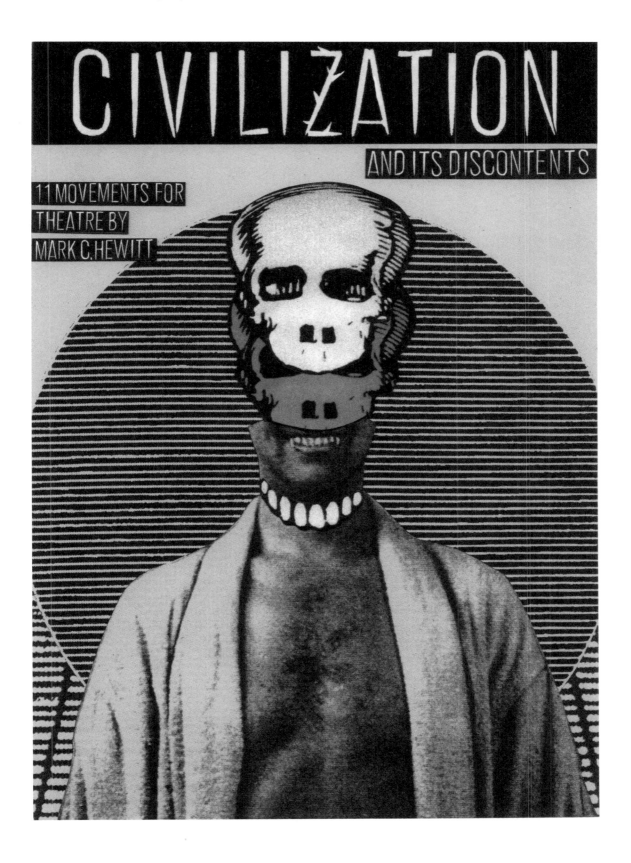

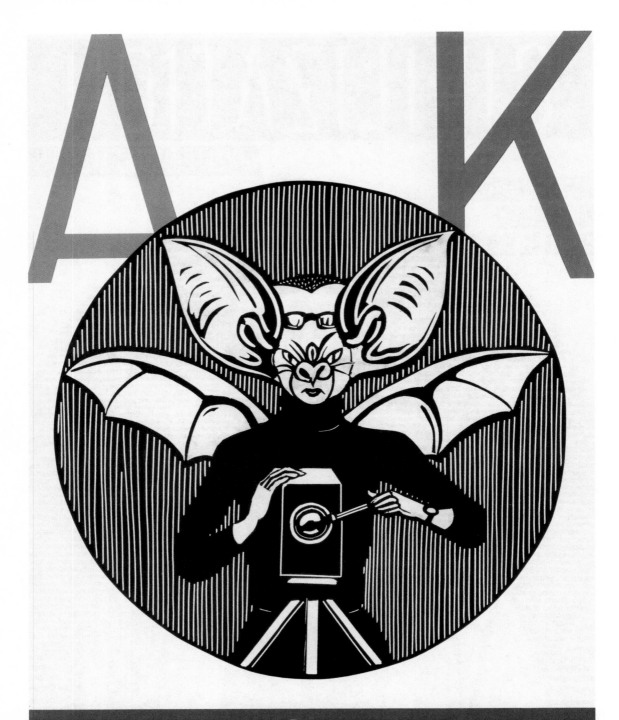

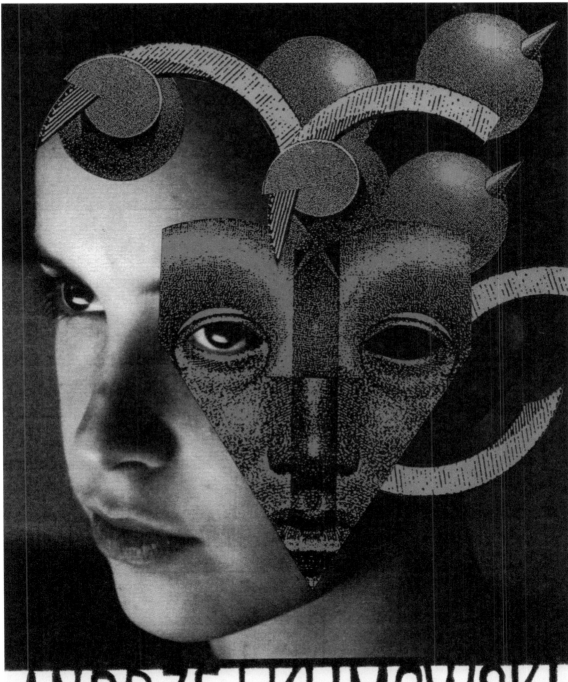

Polsko-Japońska Akademia Technik Komputerowych | ul. Koszykowa 86 Warszawa | Aula Główna

10.05.2016 godz. 17:00 wykład otwarty i projekcja filmu „Martwy Cień" | 10–22.05.2016 wystawa plakatu i ilustracji

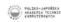

BIOGRAPHY

Andrzej Klimowski was born in 1949. He studied sculpture and painting at St Martins School of Art in London and poster design under Professor Henryk Tomaszewski at the Warsaw Academy of Fine Arts. In 1973-1980, he lived and worked in Poland. He has taught at the RCA in London from 1983 to 2016, from 2006 as Professor of Illustration. He is a Visiting Lecturer at the Polish/Japanese Academy of Digital Technology in Warsaw.

Individual Exhibitions:

1980 Galeria Wielka 19, Poznań
1981 Galeria Grażyny Hase, Warsaw
1986 Vanessa Devereux Gallery, London
1988 Vanessa Devereux Gallery, London
1996 Biuro Wystaw Artystycznych, Wrocław
2000 Comune di Lucca Villa Bottini, Lucca
2001 Royal National Theatre, London
2002 Shire Pottery Gallery and Studios, Alnwick
2002 The EICH Gallery, University of Lincoln, Hull
2002 Polish Cultural Institute, London
2003 National Museum of Photography, Film and Television, Bradford
2006 Galeria Arsenał, Poznań
2013 Kawiarnia Relaks, Warsaw, Wybrzeże Theatre, Gdańsk
2014 Polish Poster Gallery, Wrocław
2016 Polish Japanese Academy of Digital Technology, Warsaw Galeria Sztuki, Płock

Public Collections:

National Museum, Warsaw
Poster Museum, Warsaw
National Museum, Poznań
Stedelijk Museum, Amsterdam
Library of Congress, Washington DC
Californian Museum of Science and Technology, Los Angeles
Museum of Modern Art, San Francisco
Cooper Hewitt Museum of Design, New York
Musee des Arts Decoratifs, Paris

BIBLIOGRAPHY

Books by Andrzej Klimowski:

1994 *The Depository: A Dream Book* (Faber & Faber, ISBN 0-571-17286-5)
1995 *Picasso for Beginners* [with Andrew Brighton] (Icon Books, ISBN 1-874166-29-3)
1996 *Kant for Beginners* [with Christopher Want] (Icon Books, ISBN 1-874166-41-2)
2000 *Introducing Walter Benjamin* [with Howard Caygill and Alex Coles] (Icon Books, ISBN 1-84046-165-9)
2001 *Magazyn snów* (Słowo/Obraz Terytoria, Gdańsk, ISBN 83-88560-51-4)
2001 *Klimowski, a Retrospective Exhibition at the National Theatre* (Oberon Books, ISBN 1-84002-263-9)
2002 *The Secret* (Faber & Faber, ISBN 0-571-20688-3)
2007 *Horace Dorlan* (Faber & Faber, ISBN 978-0-571-23221-5)
2008 *The Master and Margarita* [with Danusia Schejbal] (SelfMadeHero, ISBN 978-0-955285-67-7)
2009 *Dr Jekyll and Mr Hyde* [with Danusia Schejbal] (SelfMadeHero, ISBN 978-0-955816-92-5)
2011 *Robot...* [with Danusia Schejbal] (SelfMadeHero, ISBN 978-83-61081-63-0)
On Illustration (Oberon Books, ISBN 978-1-849431-12-5)
2015 *Behind the Curtain* [with Danusia Schejbal] (SelfMadeHero, ISBN 978-1-906838-96-6)

2016 **Stardust Nation** [with Deborah Levy] (SelfMadeHero, ISBN 978-1-910593-13-4)

Articles on Klimowski in Books:

1983 Philip B. Meggs, **A History of Graphic Design** (Allen Lane), p.453.

1990 Cohn Naylor (Editor), **Contemporary Designers** (St James Press, Chicago), p.298-300.

1990 Walter Amstutz (Editor), **Who's Who in Graphic Art, Volume 2** (de Clivo Press, Dubendorf), p.260.

1992 Alan and Isabella Livingstone, **Encyclopaedia of Graphic Design and Designers,** p.114.

1993 Helena Rubinstein, **The International Poster Exhibition**, Tel Aviv (Tel Aviv Museum of Art)

1998 Rick Poynor, **Design Without Boundaries (Visual Communication in Transition)** (Booth-Clibborn Editions), p.169-74.

2000 **17th International Poster Biennale Warsaw** (The Poster Museum in Wilanów), p.193-4.

2003 Angus Hyland and Roanne Bell, **Hand to Eye** (Lawrence King), pp.139-141
Emily King, **Movie Poster** (Mitchell Beazley), pp.172-173

2005 Roanne Bell and Mark Sinclair, **Pictures and Words, New Comic Art and Narrative Illustration** (Lawrence King)
Agnieszka Taborska, **Topor et Cie (Roland Topor et les artistes contemporains polonais d'imagination panique)** (Aix-en-Provence Galerie Zola)

2010 **Le Gun 1,2,3** (Mark Batty Publisher, LLC, New York, ISBN 978 0 9817805 0 4)
Rick Poynor, **Uncanny: Surrealism and Graphic Design** (Moravian Gallery, ISBN 978 8 07027 214 5)

2013 Angus Hyland and Angharad Lewis, **The Purple Book** (Lawrence King, ISBN 978 1 78067 125 3), pp.136-154

2015 Ewa Satalecka (editor Jacek Mrowczyk), **Very Graphic, Polish Designers of the 20th Century** (Adam Mickiewicz Institute, Warsaw, ISBN 978 8360 263181), pp.366-371

2017 Bartosz Klonowski, **The Best Polish Illustrators 3/Posters** (SLOW Foundation, Warsaw), pp.140-143

Articles on Klimowski in Journals:

1978 Szymon Bojko, 'Global New Waves in the 1970s (Poland)', **Graphic Design 71**, Tokyo

1978 Szymon Bojko, 'Andrzej Klimowski', **Art & Artists 9**, London

1986 Graham Vickers, 'The Polish Connection', **Blueprint 29**, London

1989 Simon Banner, 'High Tension', **Graphics World** (May/June)

1991 'Andrzej Klimowski', **Studio Voice 2, 182**, Tokyo.

1994 Rick Poynor, 'Theatre of Dreams', **Eye 14**, London

1994 Veronica Horwell, 'Graphic World Without Words', **The Guardian**, 24 April.

1994 Adam Zeman, 'The Freshness of a Dream', **The Ernes**, 13 October

1995 Christopher Priest, 'Lost for Words', **The Independent**, January

1996 Igor Klikovac, 'Andrzej Klimowski, the Unconsciousness Revisited', **Idea 257**, Tokyo

2001 Nick Smurthwaite, 'Demons in the detail', **Design Week**, 6 December

2001 Annalee Mather, 'Prints Charming', **The Evening Standard**, 14 December

2001 Lessica Luck, 'Andrzej Klimowski', **The Guardian**, 15 December

2002 Richard Cork, 'Best Shows in London — Andrzej Klimowski at the National Theatre', **The Times**, 12 January

2002 William Parker, 'A Small but Perfectly Formed Prize', **Financial Times**, 16 January

2002 Andrzej Borkowski, 'Andrzej Klimowski', **Tydzien Polski**, London, 9 February

2002 Faye Dowling, 'The Secret by Andrzej Klimowski', **Eye 45**, London

2002 Francesca Gavin, 'World Without Words', **Dazed and Confused**, March

2002 Rachel Campbell-Johnston, 'A Surreal Mystery without Words', **The Times**, 3 April

2002/3 Andrzej Klimowski, 'Days of Speed', **The AOI Journal**, pp.16-21

2007 Peter Gyllan, 'The Metaphors of Andrzej Klimowski', **Novum 5**, pp.68-71
Nick Gerrard, **Literary Review 7**, p.47
Michael Moorcock, 'The Music of Science', **The Guardian**, 16 June
James Lovegrove, 'Horace Dorlan', **Financial Times**, 28 June

2010 Grzegorz Sowula, 'Eight Decades of Faber', **2+3D, no.35** (Kraków), pp.24-34

2012 Marcin Gizycki, 'Poet of Consciousness and Dreams', **Neshan 28, The Iranian Graphic Design Magazine**, pp.63-60

2017 Ben Perdue, 'The Polish Provocateur of Poster Design', **Another Man Magazine, issue 25**, pp.22-24

1995 National Arts Library Awards for Illustration, Honorary Prize, V&A, London

1999 D&AD Silver Award for Royal Mail Millennium Stamp

2007 Second Prize for Book Illustration, V&A Illustration Awards

2009 Honorary Prize at the XII International Biennale of Theatre Posters, Rzeszów

Clients include:

Faber & Faber, The Guardian, The Observer, The Times, Oberon Books, Icon Books, Penguin, Editions du Seuil, Czytelnik, Edition Robert Lafont, Picador, Pentagram Design, Trickett & Webb, Esterson/Lackersteen, Teatr Powszechny w Warszawie, Teatr Polski we Wrocławiu, Teatr Nowy w Poznaniu, Royal Shakespeare Company, National Theatre, Theatr Clwyd, Channel Four, Royal Mail, Teatr Wybrzeże w Gdańsku, SelfMadeHero, Another Magazine, World of Interiors Magazine, Przekrój Magazine (Warsaw), Pocko (London/Berlin), Everyman Library, Overlook Press (NY), Pushkin Children's Books.

Awards include:

1977/8 Key Arts Awards for Best Film Poster (Foreign Category), Hollywood Reporter, Los Angeles

1978 First Prize for Poster for Russian films screened in Poland (Russian Cultural Institute, Warsaw)

1981 Honorary Prize, Polish Poster Biennale, Katowice

1987 Silver Award, Campaign Poster Awards

1988 The Daily Telegraph Award for Excellence for press campaign for BT

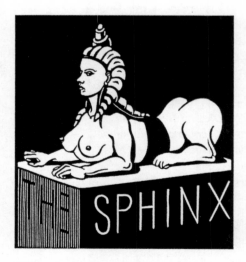

Still from Andrzej Klimowski's The Sphinx (Irish Film Board, Dublin 2006).